Arctic Journeys
Ancient Memories
Sculpture by
Abraham
Anghik Ruben

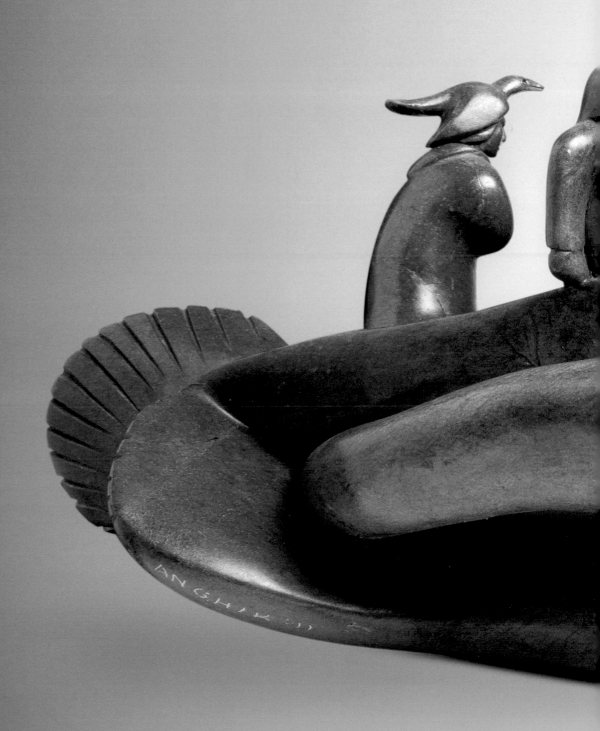

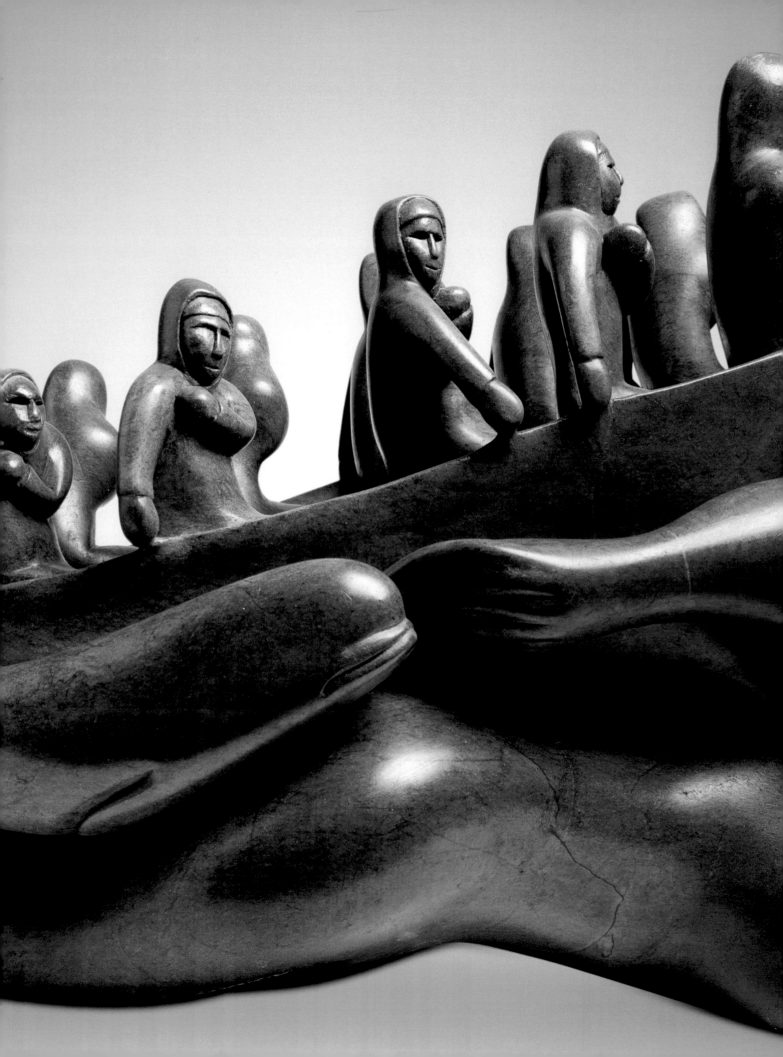

Arctic Journeys
Ancient Memories

Sculpture by Abraham Anghik Ruben

The Arctic Studies Center
National Museum of Natural History

and the

National Museum of the American Indian

Smithsonian Institution

in association with

Kipling Gallery

Published by
ARCTIC STUDIES CENTER
Department of Anthropology
National Museum of Natural History
Smithsonian Institution
PO Box 30712, MRC 112
Washington, D.C. 20013-7012
www.mnh.si.edu/arctic

ISBN- 978-0-9816142-1-2

Catalogue of an exhibition organized by the Smithsonian's Arctic Studies Center
with assistance from Kipling Gallery, Woodbridge, ON
and presented October 4, 2012 – January 2, 2013 at
The National Museum of the American Indian

Curated by Bernadette Driscoll Engelstad

Arctic Journeys, Ancient Memories:
Sculpture by Abraham Anghik Ruben
was produced by Perpetua Press, Santa Barbara
Edited by Letitia Burns O'Connor
Designed by Dana Levy
Printed in Canada by Colour Innovations

Object photography by Daniel Dabrowski, Silvio Calcagno, Alan Bibby, and Ernest P. Mayer

FRONT COVER: *To Northwestern Shores*, 2008 (Detail)

BACK COVER: FAR LEFT: *Inuvialuit: Inuit Way of Life*, 2011

CLOCKWISE FROM TOP LEFT:
Celtic Monk: Keeper of Light, 2007
Memories: An Ancient Past, 2010
Sedna: Life Out of Balance, 2006
Odin, 2008
Study for Shaman's Message III, 2011
Migration: Umiak with Spirit Figures, 2008

CONTENTS

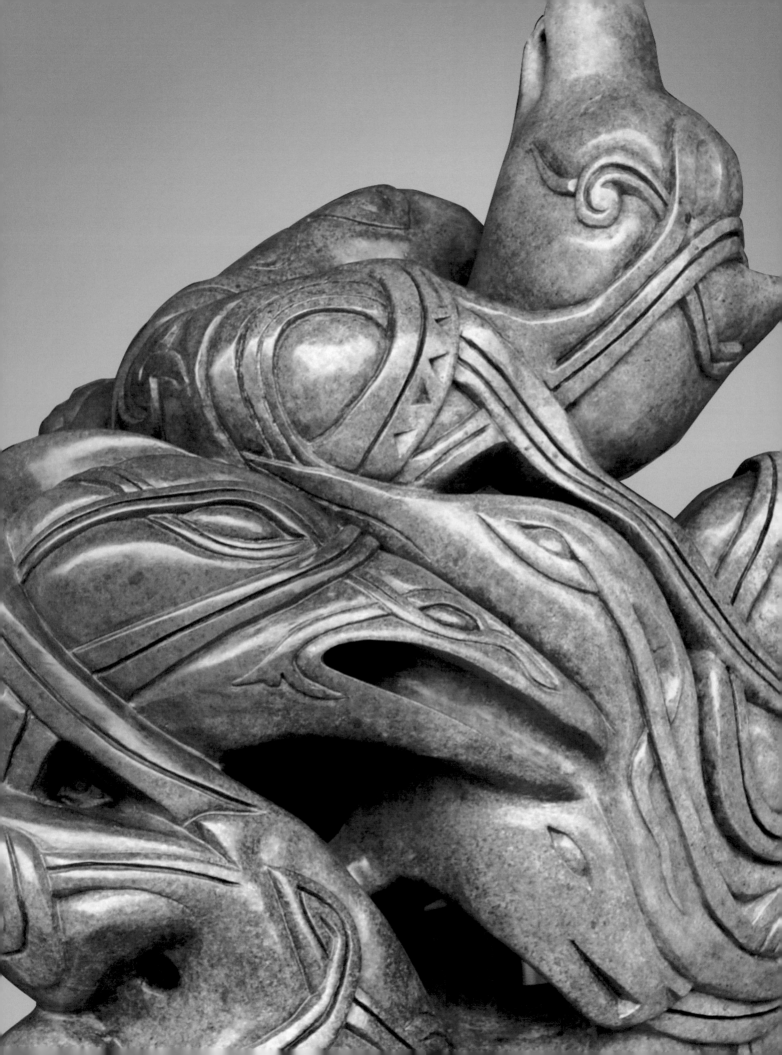

PREFACE

AS THE DIRECTOR OF THE NATIONAL MUSEUM OF THE AMERICAN INDIAN, I frequently watch as exhibitions grow out of good ideas that gather energy as they are researched and discussed, written and organized and installed. It's a thrilling process, and the presentation of work by contemporary artists can be especially gratifying, because it often links our past with our present lives in particularly compelling ways. Such is the case of *Arctic Journeys, Ancient Memories: Sculpture by Abraham Anghik Ruben*.

Arctic Journeys, Ancient Memories features twenty-three pieces by this master sculptor, widely celebrated for his ability to tell us about deep histories in new ways. His massive, intricately carved narratives speak not only of Inuit prehistory and settlement but of Viking legends and forays into the New World. The results are astounding, not just in terms of their great beauty and craftsmanship, but also the dialogues they present about ancient and living northern cultures.

I'd like to offer our profound gratitude not only to Abraham Anghik Ruben for his remarkable vision, but many thanks also to our collaborators on *Arctic Journeys, Ancient Memories*—the Smithsonian's Arctic Studies Center at the National Museum of Natural History and the Kipling Gallery (Toronto). And to you, whether you've long admired Ruben's work or are just about to discover it: you're in for a treat.

KEVIN GOVER (PAWNEE)
Director, National Museum of the American Indian

Detail of *Odin: Shape Shifter*, plate 3

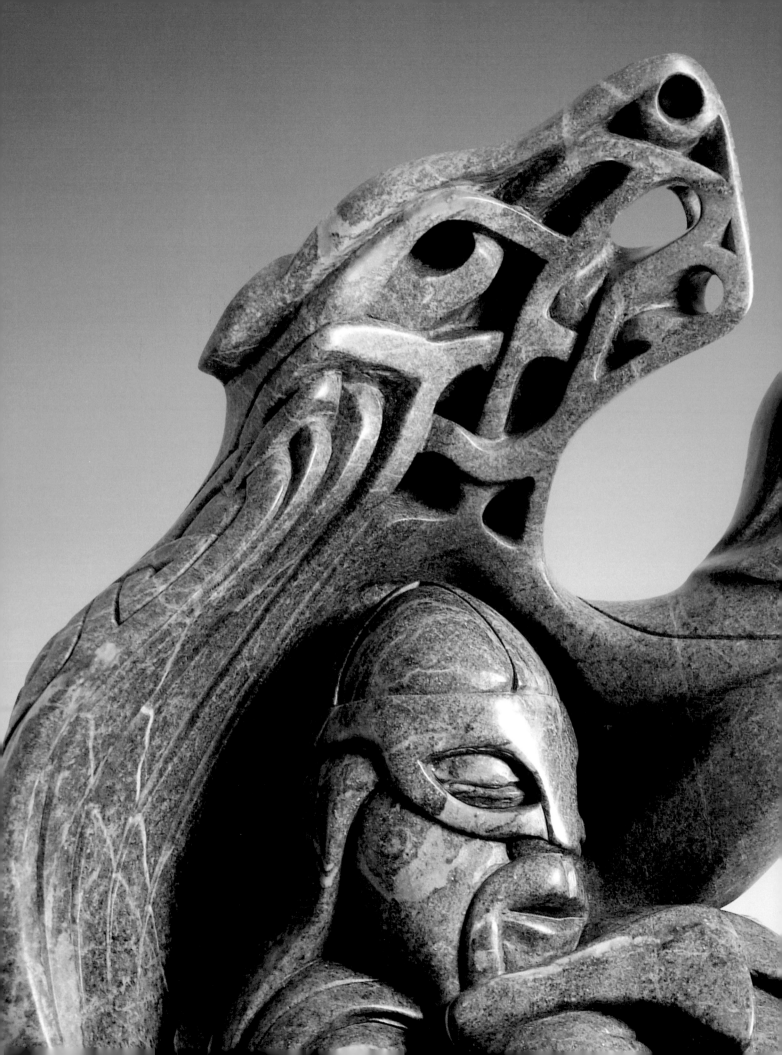

FOREWORD

ARCTIC JOURNEYS, ANCIENT MEMORIES: SCULPTURE BY ABRAHAM ANGHIK RUBEN marks a major turning point in the contemporary history of Inuit art. Here, after more than a century in which Inuit artists mined their life experiences, their memories and oral traditions, and their deep appreciation and understanding of their Arctic world—especially its animals and spirits—to communicate visually with Westerners, Ruben explores the new theme of the historical mixing of peoples and cultures in this part of the world. Rather than expressing a view of a world with Inuit at its center, Ruben interprets his and his people's exposure to the crosscurrents of history, in particular the Inuit's first experiences with European visitors to the North American Arctic. Such a comprehensive perspective in a single body of work has never before been taken by a modern Inuit artist.

On the other hand, Ruben's new conception of a more interactive global Arctic world is not wholly original, even given his clarity of vision and exceptional technique. To the cultural historian, his perspective recalls works of art and design styles known from the archaeological record going back thousands of years. His Urnes-like surface design tracery evokes eleventh-century Irish-Nordic tradition (figure 3) as much as it does the ancient art of the Okvik and Old Bering Sea (Eskimo) cultures of Bering Strait (figure 4) in the early centuries of Arctic habitation. His "autographical" images of Europeans suggest Nordic-Irish people with whom he personally shares modern genomic heritage, as well as centuries of interaction between Inuit and European cultural traditions of the past thousand years, ranging from early Viking contacts (figure 1) to the European whaling era in coastal Alaska and the western Canadian Arctic.

Ruben boldly navigates a course through these historical currents with an all-encompassing vision. His art takes for granted the certainty of intercultural contacts that archaeologists, historians, and geneticists are only now beginning to decipher. With an artist's prerogative, he sweeps aside scientific doubts about just how significant these connections were—or even, in some cases, if Viking contacts occurred at all, at least in the Western Arctic. Eventually scientists will have their day in the limelight—perhaps expanding upon the Smithsonian's past exploration of this topic in the millennial exhibition, *Vikings: the North Atlantic Saga* and

FAR RIGHT:
Fig. 1: "Bishop of Baffin" 13th-c. Thule-carved wooden figure of Norseman in a long cloak. Courtesy of the Canadian Museum of Civilization.

<<< Detail, *Thor. AD 900*

9

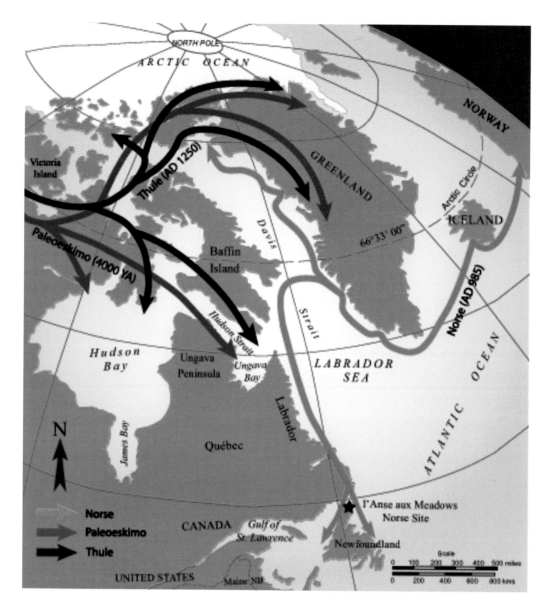

Fig. 2. Norse movement westward toward North America (Iceland, Greenland, Newfoundland, Baffin Island) and waves of Paleoeskimo (4,000 years ago) and Thule (from AD 1250) movement eastward across the North American Arctic.

its companion catalogue! Until then we have the honor of being guided by Ruben's vision of the future's past that is as elegant and inspiring as it is provocative and revolutionary. Ruben's sculptures, wrapped in layers of Inuit tradition, intuition, art, and myth also integrate history, biography, and science.

We can be thankful that the marvelous, circuitous path of his life led him to us at this time and place, an exhibition venue at the National Museum of the American Indian that coincides with the 18th Inuit Studies Conference (fig. 5) hosted by the Smithsonian. While many of Ruben's sculptures have been exhibited in Canada, they are rarely seen in the United States (previously only at the de Young Museum). Several of the works exhibited at the Smithsonian under the expert guidance of Bernadette Driscoll Engelstad, who curated the exhibition and contributes this catalogue's scholarly essay, have never before been included in a public museum exhibition.

Arctic Journeys would never have appeared at the Smithsonian were it not for our earlier acquaintance with Abraham through the good offices of Judith Varney Burch, who had the foresight to introduce me to Abraham and inspired me to explore with him the Smithsonian's anthropological collections from Alaska over several days in May, 2008. A videotape of that encounter has become part of the

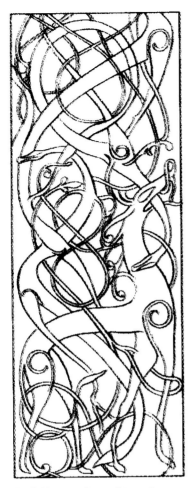

Fig. 3. Urnes-style graphic squib

Arctic Studies Center collections. Then, two years ago, when we were considering the possibility of hosting the 18th Inuit Studies Conference, Landis Smith introduced me to Roslyn Tunis, who had been working with Abraham for the exhibition Shaman's Dreams, shown at the Art Gallery of Mississauga, Ontario, in 2010. At the time, I was looking for a lead exhibition to accompany the ISC conference, and Roslyn urged me to consider Abraham's work. Abraham was delighted with the idea; the National Museum of the American Indian offered a venue; and Bernadette Driscoll Engelstad agreed to curate the exhibition. A crucial role in carrying out the plan fell to Rocco Pannese, whose Kipling Gallery in Toronto is Abraham's commercial representative. Working closely with our curator and the staff of the National Museum of the American Indian, Rocco negotiated with the lenders who generously agreed to have their sculptures included in the Smithsonian exhibition at NMAI. The Kipling Gallery also assisted in securing financial support from sponsors, assembled the selected works for photography and shipment, and helped with the onerous task of acquiring the necessary permits to ensure the inclusion of Abraham's impressive whalebone and ivory tusk sculptures.

At the Smithsonian, a large assemblage of people has enabled the exhibition and production of this catalogue. The Arctic Studies Center offers our thanks to Kevin Gover and the staff of the NMAI for their enthusiastic support of this exhibition. In particular, we thank Karen Fort and Jennifer Tozer for their expert attention to detail in overseeing the exhibit's preparation; Rosemary Regan for her keen eye and editorial assistance; Eric Christiansen for the impressive installation design; Rajshree Solanki, and Liz Hunter for their critical contributions. We are grateful, too, to Charley Potter, Chris Crane, Lauren Marr, Lindsey Burkholder, Aoife Toomey, and Laura Sharp of the larger Smithsonian community for their vital help and support. Our heartfelt appreciation also goes to our colleagues, Dana Levy and Tish O'Connor of Perpetua Press (Santa Barbara, California) for editing and designing the striking publication that accompanies this exhibition.

Finally, we join NMAI Director, Kevin Gover, in acknowledging the singular contribution of Abraham Anghik Ruben in making this exhibition possible.

WILLIAM W. FITZHUGH
Director, Arctic Studies Center
Program Chair, 18th Inuit Studies Conference

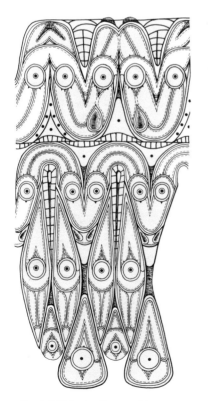

Fig. 4. Old Bering Sea graphic art

Fig. 5. Dorset soapstone figurine from Shuldham Island, Labrador, which has been adopted as the logo for the 18th Inuit Studies Conference. Courtesy of the Newfoundland Museum.

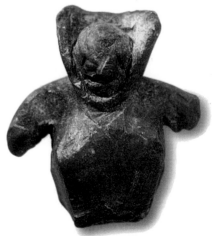

ARTIST'S STATEMENT

I AM AN ARTIST OF INUVIALUIT ANCESTRY, AND I ACTIVELY PURSUE MY ARTISTIC interests in contemporary sculpture, design, stone quarrying and prospecting. A film about Canadian geology by the National Film Board made a strong impression on me at a young age, especially the ending where the geologist was shown hammering away on a rock face. I told my teacher that I was going to be doing just that when I became an adult. Another time I surprised the same teacher with several animals made of paper maché that I had done on my own from photos.

After eleven years at an Inuvik boarding school, I left in 1970 not having completed grade 10. But I knew that the occupation and life of an artist was meant for me. In January 1971 I enrolled at the University of Alaska's Native Art Center where I tutored under Ron Senungetuk. My studies at the center resumed again in 1974–75. After leaving school in 1975, I took it upon myself to continue my formal education "on the road." My acquaintances, be they artists or craftsmen, became my teachers. I have always kept myself open to any and all possible avenues of artistic expression in an effort to understand the subtle nuances and emotions related to the creation and appreciation of art.

Throughout the years I have had many teachers and mentors. However, one individual stands out as a spiritual guide, friend, and mentor: Fabian Burbeck. This wonderful person nurtured within me an understanding of the inner workings of the spirit. I was very receptive to these ideas, for my own Inuit background spoke of the concepts of the soul (*Inua* in Inuit), reincarnation, dreams, spirit travel, and invisible worlds. As an artist I am impelled to speak of these changes in my life. All these events have influenced and led me to a further understanding of the subtle and underlying nuances and meaning of life and living.

I have always been of the strong opinion that the creation and appreciation of art is an entirely cross-cultural and international preoccupation, that no one group or continental enclave has dominion over the creative genius of art. These beliefs are contrary to opinions held by certain leading authorities on art who view its history as an entirely European creation and further believe that only those of European ancestry could possibly create and aspire to this noble activity. As an artist, I feel that these opinions do a great disservice to us all as individuals and to this country as a whole.

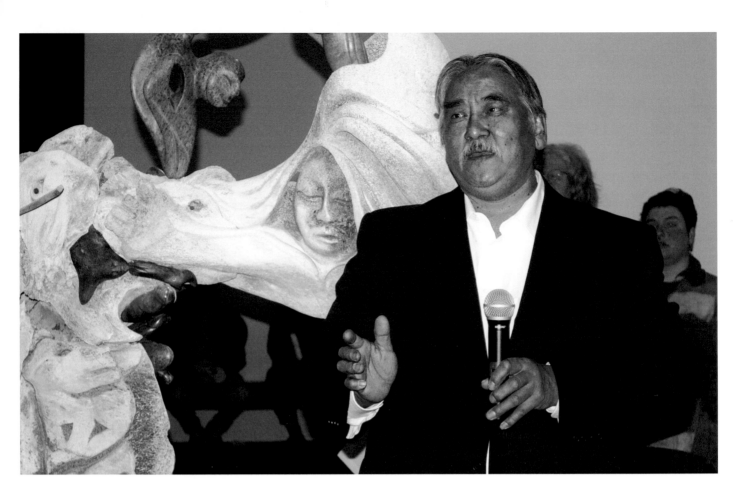

Artist at exhibition opening, *Abraham Anghik Ruben: Shaman's Dream*, Art Gallery of Mississauga, 2010

The creative forces that compel us as artists are the result of our formative years, our training, and individual experiences. The inspiration comes from within, married to the innermost thoughts and feelings. This tangible evidence of the inner workings of spirit creates an empathetic audience—an audience that appreciates and can relate to the artist's creative endeavours. These individuals appreciate the works on an aesthetic, emotional, spiritual, and intellectual level.

I have chosen to be a storyteller for my people through the medium of sculpture. Within these images, I attempt to evoke a range of thoughts, feelings, and emotions stirring within the audience; these same thoughts, feelings, and emotions I have wrought into my work. I no longer speak my mother tongue, yet I need to do my part in carrying on the stories and cultural myths, legends and spiritual legacy of our people. My hope is that my hands and spirit within will allow me this one gesture.

ABRAHAM ANGHIK RUBEN

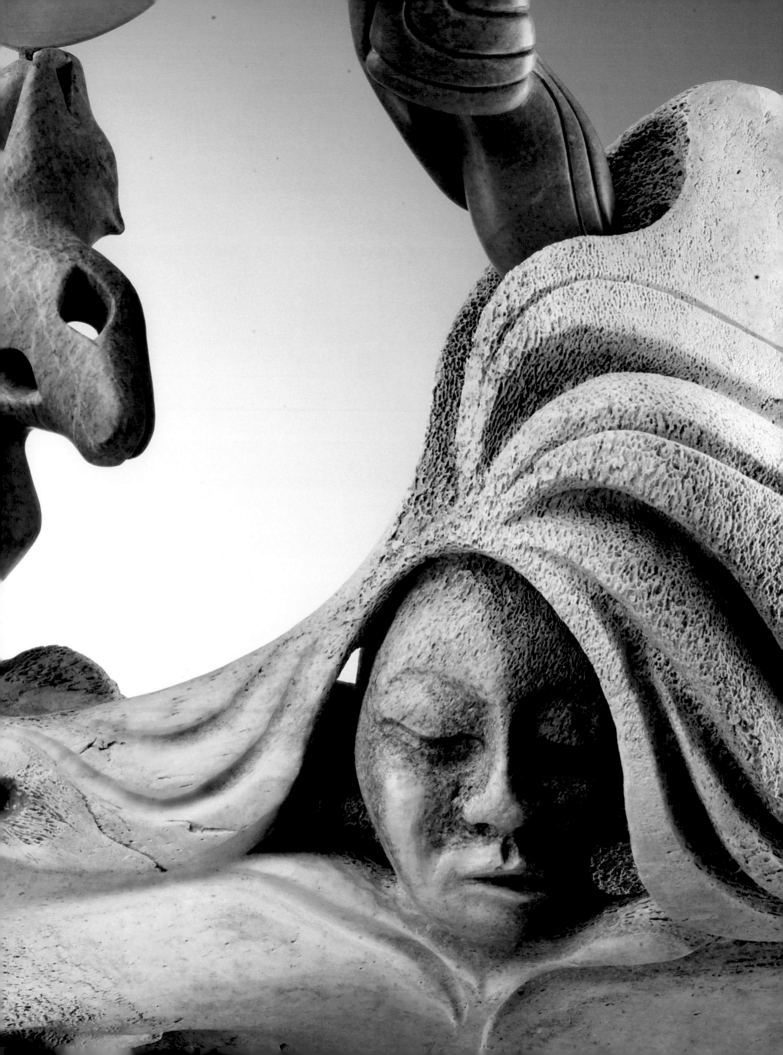

ARCTIC JOURNEYS
ANCIENT MEMORIES
SCULPTURE BY
ABRAHAM ANGHIK RUBEN

By Bernadette Driscoll Engelstad

A THOUGHTFUL AND REFLECTIVE INDIVIDUAL, ABRAHAM ANGHIK RUBEN conveys an artistic vision that has been shaped by stratified layers of history and emerges from his personal experience, artistic training, and ancestral legacy. His life—and that of his family and ancestors—has been a journey marked by change, adaptation, and resilience. These powerful forces have set him on an independent course as a contemporary visual artist.

In *Arctic Journeys, Ancient Memories,* Ruben introduces the viewer to the social, cultural, and spiritual life of two Arctic peoples: his Inuvialuit (Inuit) ancestors, skillful whale-hunters who settled in the Mackenzie Delta region, the border area that now separates Alaska and Canada's western Arctic; and the Viking adventurers and Norse settlers who spread westward from Scandinavia, establishing farming communities in Iceland and Greenland, along with transitory settlements in Newfoundland and Canada's eastern Arctic. Through the twenty-three sculptures in this exhibition, Ruben explores parallel themes of mythology, migration, settlement, and contact history from ancient Norse and Arctic Native traditions, focusing on the shared nature of the human journey—physical and spiritual, individual and collective. Envisioned in creative and diverse ways, Ruben's sculptures portray maritime adventure and exploration; displacement; contact and trade; illness and death; and, most emphatically, the human quest for spiritual knowledge and connection with the spirit world.

Arctic Journeys, Ancient Memories: Sculpture by Abraham Anghik Ruben awakens the viewer to the vital maritime orientation of the Arctic, a region of the world emerging anew in the global consciousness. Moving beyond the limitations of time and space, Ruben provides a northern perspective on circumpolar prehistory and contact, informing and challenging the viewer to join with Inuit in the journey ahead to meet the critical and pressing demands of the New Arctic.

I. The Artist: From Storyteller to Orator

Throughout the Arctic, ancient Inuit traditions have passed from generation to generation in the retelling of myths, heroic epics,

Detail, Memories, An Ancient Past, plate 22

personal stories, songs, and poetry. The ideology and moral code of the culture lie embedded in this oral tradition, strengthening the sense of community and reinforcing the connective bond that joins Inuit, the land, and its resources. Since ancient times, Inuit have created a visual legacy preserved in small but poignant carvings, incised implements, and clothing traditions. Sculptures in ivory, bone, and antler, as well as maps and drawings—often created at the request of explorers, traders, and whalers—have laid a solid foundation for the historic period of Native art production. Moreover, during the past fifty years Inuit artists across the Canadian Arctic have worked individually and collectively—often through community-based cooperatives—to create sculpture, prints, drawings, and textiles for the commercial art market. Building upon the oral tradition of the past, this endeavor has produced a remarkable reserve of cultural memory shaped by personal and family experience, historical events and circumstances.

Abraham Anghik Ruben was born into a family of Yup'ik and Inuvialuit ancestry, with traces of

Portuguese and Irish heritage from the whaling era. His maternal great-grandparents, Apakark and Kagun, who were widely respected for their shamanic powers, had originally lived on Nelson and Nunivak Islands, off the coast of central Alaska, and moved to Herschel Island in Canada's Yukon Territory when they were hired to pilot an American vessel to the whaling base there. Their journey mirrored the movement of many Native guides, hunters, seamstresses, traders, trappers, and whalers whose lives were uprooted by commercial whaling in the North Pacific.

Fig. 6. Herschel Island/Qikiqtaruk Territorial Park. Courtesy of the Yukon Territorial Government

This introduction of commercial whaling in 1848 brought about a seismic shift in the subsistence life of Native hunting communities along the coast of Alaska and in the western Canadian Arctic. Throughout the late nineteenth century, the American whaling fleet, based in San Francisco and New England, pursued the lucrative search for whale blubber and baleen. Whale blubber

provided a key source of oil to light American homes, factories, and cities, while baleen, harvested for domestic and industrial use, was a strong, flexible material used before the invention of synthetic plastics. Whaling captains recruited Native men as guides and crew members, and contracted with hunters to feed an ever-increasing number of whalers. Women were hired as seamstresses to produce fur parkas and boots for the captain and senior crew of the whaling vessels. In addition, fur trapping gained significance as hunters sought the means to purchase imported goods, such as rifles, ammunition, food, cloth, clothing, and whaling boats.

With the depletion of the bowhead whale population in Alaska in the 1890s, the American whaling fleet moved north to Herschel Island, transforming this Inuvialuit coastal settlement into a rowdy frontier town housing more than 1,000 whalers from around the world. Drinking, violence, and prostitution impacted harshly on Inuvialuit families throughout the region. In 1893 the Anglican missionary Rev. Isaac Stringer encouraged whaling captains at Herschel Island to

Fig 7. Whaling ship known as *Thrasher* at Herschel Island. Courtesy of the New Bedford Whaling Museum.

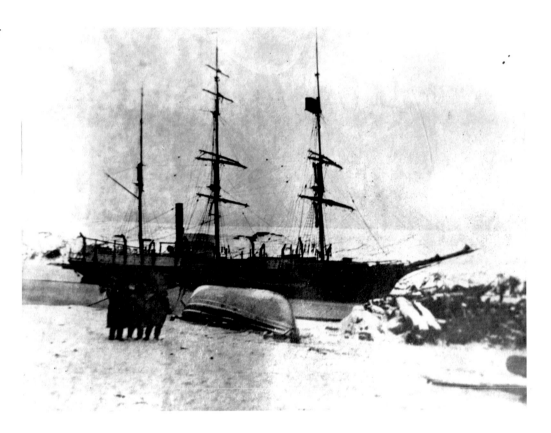

bring their wives and children with them for the following whaling season.[1] The presence of *qablunaat* (non-Native) women and children began to have a sobering effect on the social life of the whaling station.

It wasn't long, however, before a series of epidemics took its toll, threatening the very survival of Inuvialuit. Successive bouts of measles and influenza, along with venereal diseases, caused tremendous suffering and a shocking number of deaths within the Inuvialuit community. By 1907, when the whaling station at Herschel Island was abandoned, the Inuvialuit population had been almost decimated. Inupiat families from northern Alaska migrated into the Mackenzie Delta region and settled among the Inuvialuit survivors, eventually bringing about a resurgence in the local population. Other Inuvialuit moved east, pursuing opportunities as traders and trappers in less-

inhabited regions of Canada's western Arctic. These families, including Ruben's forebears, established Inuvialuit settlements at Sachs Harbour and Paulatuk, and joined with other Inuit groups, known as the Inuinnait, who had long been settled on Victoria Island.

In addition to his family history, Ruben's personal experience reflects that of a generation of Inuit born in the 1940s and 1950s to a rapidly changing world. By the early twentieth century, the whaling era of their great-grandparents had come to a close; and the fur market that had supplemented the hunting and fishing economy of their parents and grandparents was eclipsed by the Depression of the 1930s. The onset of World War II raised profound concerns for the basic security of the continent, sharpening political attitudes toward the Arctic. Military bases and radar installations, along with the introduction of government-sponsored education, housing, and medical services, as well as mining and resource development, increased the *qallunaat* (non-Native) presence across the North, profoundly changing the lives of Inuit families. As resource exploration

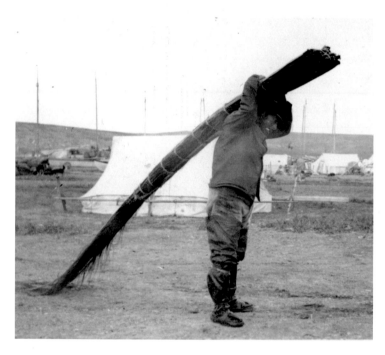 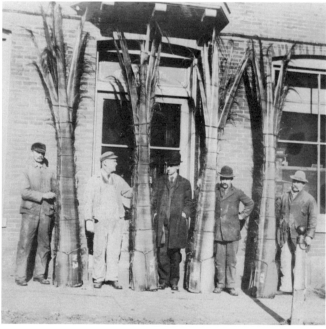

and development expands anew, this process of social, political, and economic change will only intensify across the Arctic.

At the time of his birth in 1951, Abraham's family lived a traditional camp life near the Catholic mission outpost at Paulatuk located on Darnley Bay in the Amundsen Gulf, some 170 kilometers north of the Arctic Circle. The family, which eventually included fourteen siblings (eight brothers and six sisters), moved seasonally to hunt, fish, and trap. His father William Esoktak Ruben was a well-respected hunter and trapper; and his mother Bertha Thrasher was a skilled artisan, noted storyteller, and keeper of cultural traditions. As Ruben recalls, "When we were living in Paulatuk we had no TV. Our only entertainment was the oral traditions, myths, and stories of the whaling period, camp life, and shamans told by our elders."[2]

By the mid-1950s the Canadian government instituted an education policy requiring Inuit children across the North to receive a school-based education. With no federal school in the region, children in the western Arctic were sent to residential schools operated by the Anglican or Roman

Fig. 8. Man carrying large bundle of baleen. Courtesy of the New Bedford Whaling Museum.

Fig. 9. Whaling merchant and staff with bundles of baleen. Courtesy of the New Bedford Whaling Museum.

Catholic churches, initially at Aklavik, and later at Inuvik, the newly constructed government center in the Mackenzie Delta, 400 kilometers west of Paulatuk. At the age of eight, Ruben joined his older siblings at Grollier Hall in Inuvik. They were part of a generation of young Inuit who throughout their childhood and adolescence were only allowed to return home during summer breaks to their families, who lived in small camps and remote communities across the North. Forbidden to speak their language and removed from the care of their parents and extended family, these children endured a profound sense of loss and abandonment. An early sculpture by Ruben entitled *The Last Goodbye* recalls his mother tenderly bidding farewell to two of her children as they prepared to leave for the school year (figure 10); other sculptures, *Coming to Terms with the Past* and *Wrestling with My Demons* (figure 11) allude to Ruben's own struggles in overcoming the addiction and emotional scars that afflicted many in his generation. In a public apology to Native students, the federal government of Canada formally acknowledged the emotional pain inflicted upon these students by family separation as well as, for some, criminal acts of abuse.

Fig. 10. *The Last Goodbye*, 2001
Brazillian soapstone. 42.5 x 25.5 x 42 cm

Fig. 11. *Wrestling with My Demons*, 2001
Brazillian soapstone. 78.7 x 30 x 29 cm

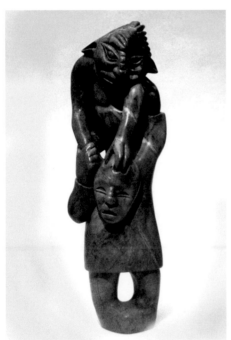

Throughout the past several decades, graduates of the residential school system have also used their education, fluency in English, and knowledge of western culture to shape leadership positions in political, social, and cultural development, media, national and international politics, and community service across the North. The residential school experience marks a point of cleavage in the work of a generation of now mature artists. For many, the time away in residential school, or in extended hospital stays in the South,[3] has impacted their art by broadening their experience, strengthening their insight, and clarifying their vision.

For Ruben the residential school experience, coupled with formal art training at the University of Alaska, has set him on a self-directed path of independence, exploration, and reflection. As Ruben has noted, "I had the good fortune to be at the right place at the right time.... In 1970 I went for a tour of the University of Alaska. I wandered off to the fine arts building and to the art studios. I looked through a small studio window where I could see the students working at their various work stations. I knew at that moment that this was where I wanted to be."[4] As a student at the

Native Arts Center at the University of Alaska, Fairbanks, where he enrolled in the summer of 1971 and returned from August 1974 to July 1975, Ruben studied with the Inupiat artist, Ronald Senungetuk, developing skills in design, carving, and printmaking. Following his studio training, Ruben began to exhibit in commercial art galleries in Toronto. In 1989 his work was featured in the exhibition *Out of Tradition,* a two-person show at the Winnipeg Art Gallery (with his brother, noted sculptor David Ruben Piqtoukun). A solo exhibition in 2001 at the Winnipeg Art Gallery featured a selection of intimate sculptures portraying family members—the source of his learning—as well as works depicting the artist's coming to terms with personal feelings of loss and separation. His sculptures are not merely recollections of the past, but interpretations of personal and cultural memories. Through his art, Ruben speaks with confidence and authority, guiding the viewer toward a fuller and deeper understanding of his personal, ancestral, and cultural history.

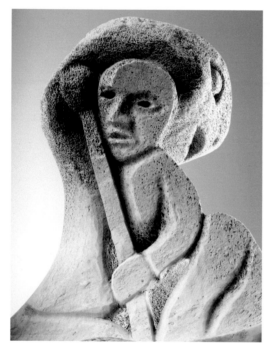

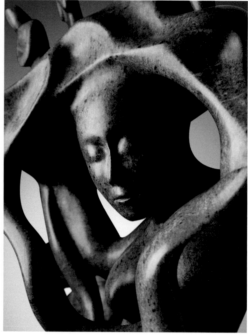

Detail, *Memories: An Ancient Past,* plate 22

Detail, *Sedna: Life Out of Balance,* plate 17

II. The Shaman *(Angakkuq)* as Guide

In the monumental whalebone sculpture *Memories: An Ancient Past* (plate 22), Ruben transforms the massive skull of a bowhead whale into a symphonic rendering of Inuit cultural history. The shaman (*angakkuq*), the principal mediator between the physical and spiritual worlds, becomes the cortex of the sculpture; his body is devoid of flesh, reduced to its skeletal essence. Flowing with carved images of Sedna, the guardian of sea animals, and Raven, the Inuvialuit creator-god, a chorus of shamanic figures—drum dancers in various states of transformation—orchestrates the movement of human, animal, and spirit images. With the assistance of helping spirits, the shaman passes freely between the natural and supernatural worlds. On behalf of the community, the shaman—whether male or female—searches out game, locates lost hunters, restores the souls of the sick, and accompanies the souls of the dead to the afterlife. A pivotal figure throughout the circumpolar world, the shaman serves as guide and visionary and is a prominent and integral theme in Ruben's work.

Transcending the cultural, temporal, and spatial boundaries that separate the Norse and Inuvialuit, Ruben probes the ancient histories of both societies, highlighting their reliance on the mystical powers of shamans and other deities. Neil S. Price interprets the sagas for evidence of shamanism in early Norse culture:

> The Saga of the Ynglings describes how Odin [the primary Norse god, associated with war] could change his shape into that of an animal and in that form travel to far-off places 'on his own or other men's errands.' This latter comment is especially important, as one of the defining characteristics of a shaman is that such an individual does not work alone but rather within the context of a community and its needs.[5]

Several works in the exhibition illustrate the shaman's ability to assume the attributes of other beings. Birds, in particular, provide essential support to the shaman. Able to fly, swim, and dive,

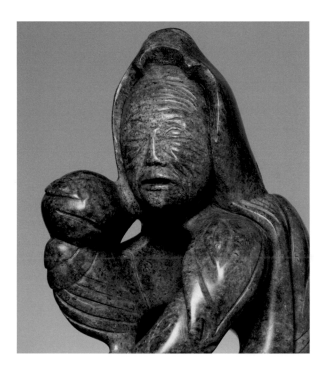

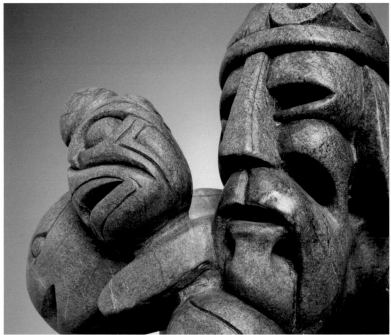

Detail: *Study for Shaman's Dream II,* plate 10

Detail: *Odin's Story,* plate 4

birds—especially loons—allow the shaman to travel through the air and underwater. In Ruben's masterful sculpture, *Odin, Shape-shifter* (plate 3), the artist illustrates Odin's ability to transform freely into the spirit forms of natural and mythological beings. Various birds and animal figures twist and turn, their remarkable energy caught in a state of arrested animation. The polar bear (known as 'water bear' or 'ice bear' in the ancient sagas) is respected by Inuit and Norse alike for its cunning intelligence, physical strength, and strategic hunting skill. Considered closely akin to humans, the polar bear is the shaman's most powerful helping spirit. In *Shaman's Dream* (plate 9) Ruben portrays a figure draped in the skin of the polar bear; deeply incised images of spirit-helpers symbolize the shaman's intimate connection with the spirit world, illustrating the ancient belief that the shaman embodied his or her spirit-helpers.

Gifts of insight and knowledge beyond the norm are often signs that predict the shaman's calling. Through a formal apprenticeship, the novice learns the cryptic language of shamanism that is used to communicate with the spirits,[6] gradually acquiring the skills of the shaman. Across the Canadian

Arctic, the *angakkuq* is charged with appeasing Sedna, the guardian of sea animals who controls the release of seals, whales, and walruses, and so ensuring the bounty of the Inuit hunt.

From her home at the bottom of the sea, Sedna holds the fate of Inuit families in her hands. Scarce game or famine signifies Sedna's displeasure. Troubled by the misdeeds of a hunter, his family, or the community as a whole, Sedna withholds her sea animals. The shaman must journey to the bottom of the sea, placating Sedna by combing her long hair, which has become tangled by the transgressions of men and women. This close association between Sedna and the shaman is evident in *Shaman's Dream* (plate 9) and the small working studies of Shamans's Dream II and III (plates 10 and 11), in which Sedna's face emerges from the back of the shaman's body.

For Ruben, the shaman's role provides an opportunity to explore the interplay between individual and community, underscoring the importance of leadership within Inuit society. In *Shaman's Dream*, the *angakkuq* pauses in mid-glance with his hands wrapped around a walking stick; head uplifted, his eyes and mind seem focused on another reality. The sculpture symbolizes the shaman's position as journeyman and spiritual guide on the human journey.

III. The Viking Journey: Norse Settlement in the New World

Intrigued by Norse territorial ambitions in the North Atlantic, Ruben emphasizes both the bold spirit of Viking adventurers and the courage, skill, and resourcefulness of Norse farmers and

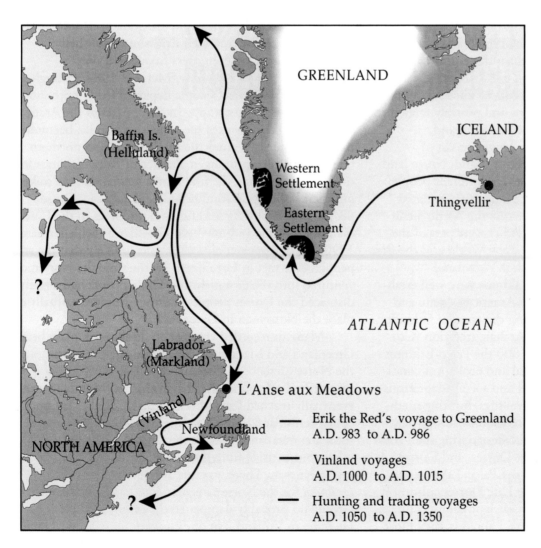

Fig. 12. Norse explorations and settlement

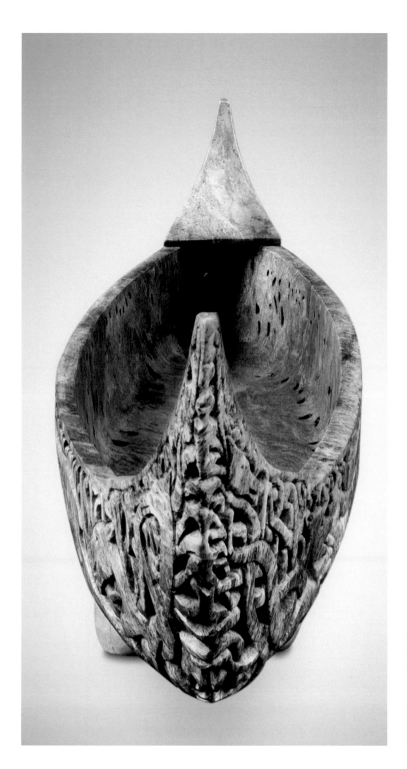

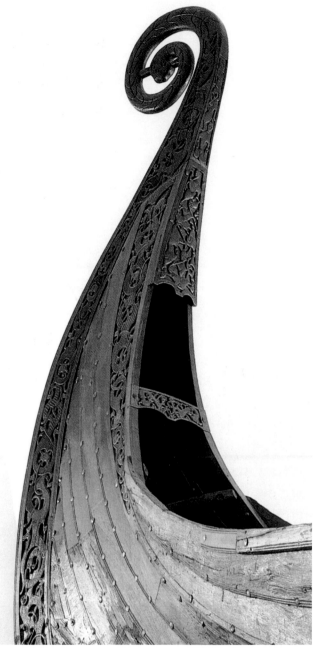

Front view, *Into the New World,* plate 7

Fig. 13. This fine example of a Viking longboat was recovered from a famous burial mound at Osberg, Norway. Courtesy of Viking Ship Museum, Oslo.

pastoralists who settled the coasts of Iceland and southern Greenland in the ninth and tenth centuries. In plate 5, Odin is positioned prominently above the ship guiding Norse settlers to new lands. In Norse tradition, Odin is often portrayed with his two helping spirits, a pair of ravens symbolizing Thought and Memory (plate 4). In plate 6, Odin's son, Thor, god of thunder, is shown within the protective embrace of the polar bear, the powerful guardian spirit of the Arctic world.

The search for timber, fertile lands, and more abundant fisheries prompted the Norse to expand their domain across the North Atlantic, establishing settlements on the Faroe Islands, Iceland, and Greenland. The skillful and imaginative rendering of stormy northern seas in Ruben's sculpture *To Northwestern Shores,* 2008 (plate 14), underscores the bold courage of these early Norse explorers.

Almost overwhelmed by the churning waves, the boat seems held aloft only by the mystical power and beneficence of the sea creatures below. The sea-faring skill of Vikings and Inuit link the circumpolar world across time and space. Both cultures owe their maritime success to the technical design and maneuverability of watercraft: the impressive Viking longboat as well as the ingenious kayak and large, skin-covered *umiak* used by Inuit from Siberia to Greenland.

A striking, comparatively lightweight wooden boat with a sweeping prow (figure 13), the longboat was designed to move quickly and stealthily. Its low draft allowed Viking raiding parties to approach coastal settlements throughout Scotland, England, Ireland, and France. Operating from bases on the Shetland and Orkney islands, the Vikings raided monasteries, towns, and cities throughout the Celtic world, which resulted in a vast accumulation of coins, weaponry, embroidered textiles, gold and silver, often rendered in finely wrought jewelry and metalwork. By the end of the ninth century, Dublin had become an important Viking port city and trading center. Hoards of Celtic

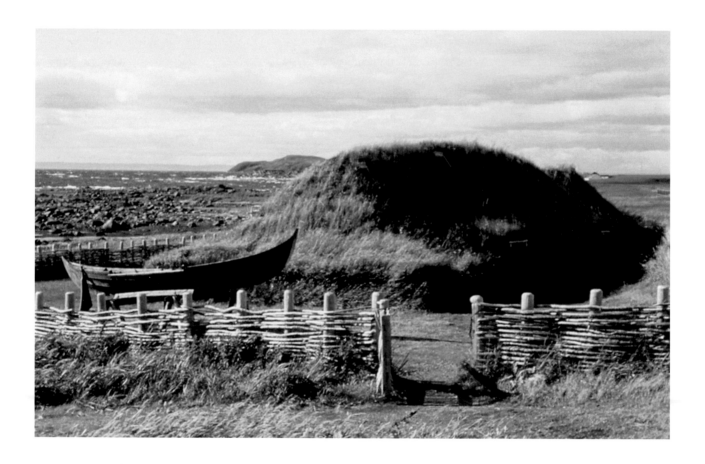

wealth, acquired through trade as well as plunder, spread Celtic design motifs and decorative art throughout the Norse world. The longboat design also allowed the Vikings access to inland rivers, a strategy that eventually (AD 845) brought them to the gates of Paris. Ruben's sculpture of a Viking longboat (plate 7) is decorated with the interlaced motifs often found in illuminated manuscripts, including the *Book of Kells,* as well as on the prow of Viking ships[7] or on weather vanes affixed to the prow.[8] The cultural and spiritual significance of the longboat is emphasized in the design of Norse boat graves destined to carry the deceased to the afterlife, accompanied by a treasury of goods acquired in this life.

The growth of monasteries as artistic and literary workshops was concurrent with the spread

Fig. 14. L'Anse aux Meadows Norse site, northern Newfoundland Archeological work enabled Parks Canada to reconstruct the only documented Norse settlement on the North American continent. The site celebrated its fiftieth anniversary in 2010 and is visited annually by thousands of visitors. (photo: Mark Allston)

of Viking power throughout the Celtic world. The beginning of the Viking era is dated to the infamous raid at Lindisfarne monastery on Britain's northeast coast in AD 793, and monasteries continued to provide worthy targets throughout the Viking period. As centers of Christian learning, monasteries were the primary source of evangelization. Scholarly writing from the early ninth century recounts the presence of Irish hermits in Iceland, predating Norse settlement toward the end of that century.[9] Ruben portrays the *Celtic Monk* (plate 15) as a penitential figure, with a walking stick symbolizing his evangelical vocation and a book of manuscripts emphasizing the Celtic role in spreading literacy while disseminating the Gospel. Adherence to Christianity brought about a transformational change in Nordic culture. Proclaimed by the Danish monarch Harald Bluetooth in the late tenth century,[10] and in Norway under Olaf Tyggvason about AD 1000, the adoption of Christianity foreshadowed the end of the Viking era, which scholars date to the Norman invasion of Britain at the Battle of Hastings in AD 1066.

Exiled from Iceland in the tenth century, Erik the Red established two settlements on the southern coast of Greenland. Ancient Icelandic sagas recount his adventures, as well as those of his son, Leif Eriksson, whose expeditions to the New World lead to the discovery of places identified in the Norse Sagas as Helluland, Markland, and Vinland. In 1960 the Norwegian archaeologists Helge Ingstad and Anne Stine Ingstad unearthed evidence of a Norse settlement on the coast of Newfoundland, confirming the veracity of these ancient sagas. Excavations continue at L'Anse aux Meadows, which was recognized as the first UNESCO World Heritage Site and is designated as a Canadian National Historic Site.[11] Recent excavations on Ellesmere Island by archaeologist Peter Schledermann,[12] as well as on northern Baffin Island by archaeologist Patricia Sutherland,[13] provide further evidence of the Norse presence in Canada's eastern Arctic.

Fig. 15. Detail, *Celtic Monk: Keeper of Light.* Bronze cast of plate 15, 2012 Collection of Mario Pestrin.

IV. The Inuvialuit: Journeys and Memories

Although the kayak is the better-known invention, it was the *umiak*, a large open skin-covered boat with a skeletal frame of driftwood or whalebone, that allowed the Thule ancestors of contemporary Inuit to set out from Alaska between AD 1000 and 1250. Warming environmental conditions opened new routes for migrating whales, on which Thule families were able to support themselves as they journeyed eastward. Canadian archaeologist Robert McGhee points out that trade opportunities and the search for metal, particularly for iron, further stimulated Thule migration.[14] Within the remarkably brief period of two hundred years, the Thule culture spread over 4,000 kilometers from northern Alaska to Greenland. Well-adapted to maritime hunting, the Thule culture displaced the earlier Dorset culture, known as *Tuniit* in Inuit oral tradition. Archaeological evidence, as well as references to *Skraelings* (Native people) in the Norse sagas, provides clear indications of contact and trade between the Norse and Thule culture, as well as suggestions of conflict between them.

As co-descendants of the Thule culture, regional groups of Inuit throughout northeastern Siberia, northern Alaska, the Canadian Arctic, and Greenland are closely related, sharing the same language

(with regional differences in dialect) as well as similar social customs and cultural practices. The Inuvialuit of the Mackenzie Delta and the Inupiat of northwestern Alaska are both whale-hunting societies who maintained close trading relations. In mythological accounts, they are descendants of two rival brothers, who each set out to claim their own territory. For well over 1,000 years, the Inuvialuit have occupied the Mackenzie Delta region, harvesting the abundant marine life along the Arctic coast and gathering seasonally in large coastal communities. Communities were organized around the leadership of one or more *umialik*, boat owners, and heads of large extended families who were able to outfit successful whaling expeditions. The *umiak* is a repeated image throughout this exhibition (plates 14, 18, 19, 21 and 23) that also serves as a metaphor for the community, a vessel that transports Inuit and spiritual beings. In addition to beluga and small bowhead whales, Inuvialuit hunting families depended on seals as well as migrating herds of caribou. Fish, birds, and small mammals also contribute significantly to the subsistence economy. By harvesting migrating beluga and bowhead whales, Inuvialuit hunters were able to support winter camps with

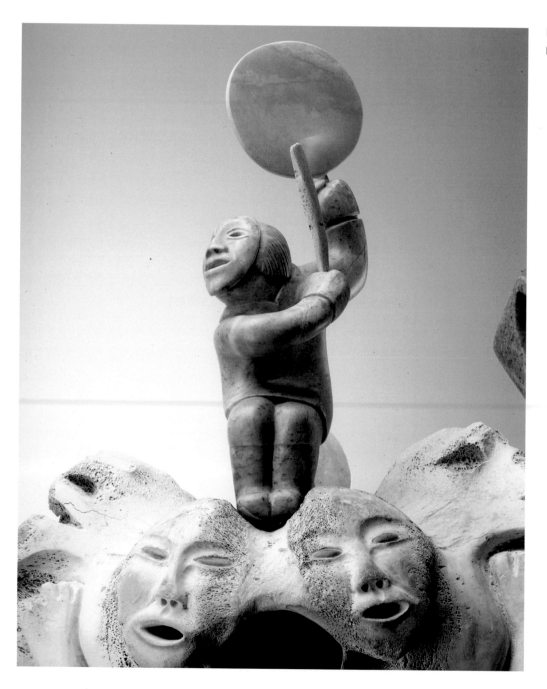

Detail, *Memories, An Ancient Past,* plate 22

populations from 75 to 300 persons, although some coastal communities had more than 1,000 inhabitants—a size unprecedented in the nomadic camps of Inuit families spread across the central Canadian Arctic.

These large communities nurtured a rich ceremonial life with ritual festivities focused on marine resources, in particular, the bowhead whale. Accompanied by the rhythm of the drum, masked dancers expressed the community's hospitality and gratitude to the whale with songs that fete the sea-mammal's unique spirit. The shaman's drum calls the community and spirits together. Across the circumpolar world, it is the medium of communication with the spirit world, recalling the journeys and memories of the past. Ruben's sculpture entitled *Memories: An Ancient Past* brings together the shaman and drum dancers with images of Sedna, animals, and the Inuit community. In the drum dance, the beat of the drum serves as the heartbeat of the community. Ruben also suggests the drum beat is analogous to a human heartbeat. In describing a young boy's experience with a premature death, Ruben writes:

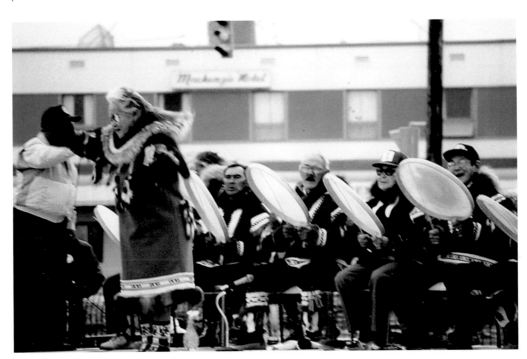

Fig. 16. Mackenzie Delta drummers and dancers perform during the Arctic Summer Games, Inuvik, 1991.

> The young boy had gone to the afterlife, travelling through a tunnel toward a bright light. As he travelled through the tunnel, he heard birds, growling bears, and howling wolves, but the steady, constant beat of a drum began to overtake his consciousness. He heard the distant drum, and within the drum he heard his own heartbeat. The drum and the heartbeat became louder and louder. He began to be drawn back to the source of the drumbeat and soon he was returned to the world of the living.[15]

V. The Journey of the Narwhal

Ruben's early training in Inuvialuit mythology and shamanistic stories gave him a keen appreciation for the ancient prehistory of the Arctic and fed his curiosity to seek out the stories of the past. In portraying cultural archetypes with understanding and conviction, Ruben awakens the viewer to the differences and significant parallels in mythology, cultural practice, and the historical reality that underlie the circumpolar experience.

Ivory has long been a medium preferred by artists and artisans across the Arctic. Not only were ivory combs and needlecases considered a woman's most valued possessions, ivory carvings preserve some of the earliest and finest indications of Arctic culture. Since ancient times, mammoth ivory, walrus tusks, and whale teeth provided the primary sources of ivory.

The narwhal, a small Arctic whale that travels in large pods in the cool northern waters along the coasts of western Greenland and Baffin Island, is another source of ivory. The long spiral tusk, which can grow to a length of five to nine feet, is found typically only on the male narwhal. Regarded as an 'ornamental device,' the tusk features prominently in dueling actions with other males. Key to courtship display, it is used aggressively in a scraping motion (known as 'raking') against the bodies of other males, as well as in a persuasive, stroking motion with females.[16] Recent research also suggests that the sensory nerves located in the tusk aid narwhals in judging water temperature and salinity, and thereby assist in timing seasonal migrations.[17]

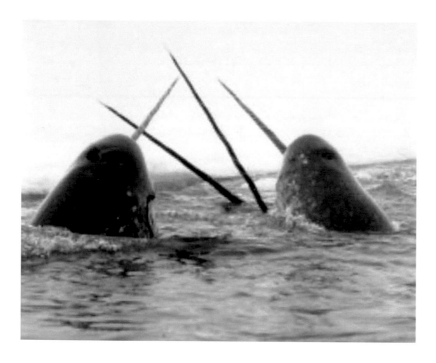

Fig. 17. Narwhals breaching near ice.
Photographer: Glenn Williams

The presence of narwhal tusks in cabinets of curiosities and cathedral collections, as well as in royal treasuries, attest to the great value placed on it as a trade item throughout Europe during the Viking Eras. Its rare and exotic nature, as well as its physical appearance, gave rise to unicorn mythology, which established its unique niche in the realm of western European art history. One wonders if the trade value of the narwhal tusk may have figured in drawing Norse explorers and traders further west toward Canada's Arctic, to where migrating narwhals continue to gather in the coastal areas of north Baffin Island.

The two narwhal tusks in the exhibition, acquired from the hunters' cooperative at Mittimatalik (Pond Inlet) on the northeast coast of Baffin Island, contrast the parallel histories of the Norse Vikings and the Inuvialuit. With figures carved in low relief, *North Atlantic Saga* (plate 2), celebrates Norse settlement in Iceland, southern Greenland, and the New World. Its carved soapstone base reveals a fluid movement of northern animals and mythological beings important to the Inuit. The base secures an impressive ivory tusk highlighting the pastoral and maritime life of Norse settlers.

Detail, *Inuvialut: Inuit Way of Life*, >
plate 16

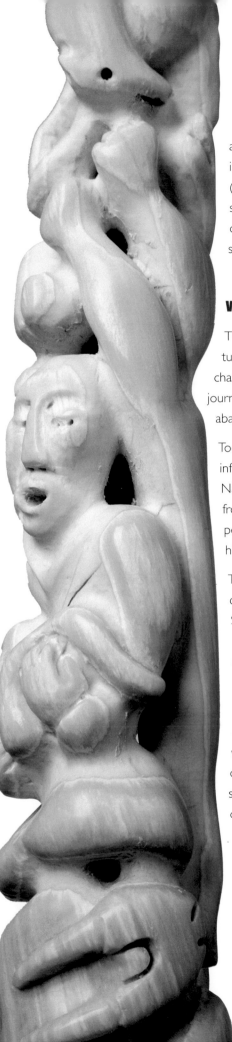

The upper area of the tusk depicts presumed trading encounters between the Norse and Native inhabitants of North America.

The second narwhal tusk sculpture, entitled *Inuvialuit: Inuit Way of Life* (plate 16), draws on Inuit mythology and cultural history. Its stone base portrays Sedna, the guardian of marine animals, and Raven, known to the Inuvialuit as creator of man and all living creatures. Other images on the tusk illustrate episodes drawn from Inuvialuit cultural history: a shaman (*angakkuq*) braiding Sedna's hair, another bringing a young boy back to life, and a third shaman carried aloft by a giant gyrfalcon. The tusk's upper area emphasizes the survival of the Inuvialuit, their dependence on the land and stewardship of natural resources, and strong resurgence as a Native community in the North American Arctic.

VI. The New Arctic: A Journey Forward

The warmer temperatures that encouraged Norse expansion into the North Atlantic turned cooler in the twelfth and thirteenth centuries with the onset of the Little Ice Age. This change in temperature not only influenced the expansion of sea ice, impacting the migratory journeys of animals, but also reduced the productivity of Norse farmlands, contributing to the abandonment of Norse settlements in Greenland by 1450.

Today, the impact of global warming is felt across the Arctic. Warmer temperatures have influenced the migratory range of animal and bird species and increased the danger for Native hunters whose fall, winter, and spring hunting depends on being able to travel on frozen ice. As warming trends persist in the Canadian Arctic, hunters are experiencing new perils in the unstable condition of ice, which is freezing later and thawing earlier than in historical memory.

The sculpture *Sedna: Life out of Balance* (plate 17) draws attention to the perils of climate change. Inspired by the Little Ice Age of the latter twelfth century, Ruben reimagines the Sedna myth, transforming Sedna's body and flowing hair into the ice that supports the Norse and Inuit figures above. The sculpture highlights the importance of ice as a source of security and livelihood for humans and animals throughout the circumpolar world.

The artist's concern for the critical situation facing Inuit across the North is evident in the sculpture *Arctic Apocalypse* (plate 1). The cluster of figures, their bodies bent in fear, drift as a huddled mass on an ever-shrinking pan of ice. In contrast, the sculpture *Migration: Umiak with Spirit Figures* (plate 21) summons the strength of the community under the leadership of the *umialik*, or ship's captain. The crew of spirit figures travels securely within the *umiak* supported by the abundant resources of whales and marine life. The two sculptures portray opposing responses to the current crisis: the first, resignation to the uncontrolled and inevitable force of Nature; the second, meeting the current challenge with confidence, leadership, and respect for the spiritual nature of the endeavor.

Through the exhibition *Arctic Journeys, Ancient Memories*, Abraham Anghik Ruben guides the viewer on a journey across time and space, comparing and contrasting the experiences of the Viking Norse and Inuvialuit in the circumpolar region. The exhibition underscores Ruben's personal journey as an artist, moving from storyteller to orator, visionary, guide, and cultural activist. With singular focus and consummate energy, Ruben projects his

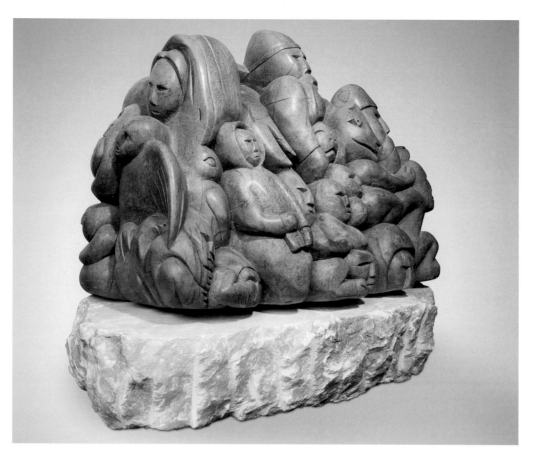

Another view of *Arctic Apocolypse*, plate 1

own artistic vision and creative voice. His skill in conveying this vision has received international recognition; his art work is collected by major museums and presented in national and international exhibitions. Through public and private commissions, his outdoor sculptures have enhanced the streetscape of Vancouver and enriched the campus of the University of Manitoba. His creativity and intellectual energy leads him on a journey to give shape and form to personal experience and ancestral memory, creating objects of beauty, strength, and meaning that provide unique and valuable insights into the ancient history and cultural foundation of North America.

NOTES

1 http://www.museevirtuel-virtualmuseum.ca/sgc-cms/expositions-exhibitions/eveque-bishop/english/logchurch.html 2002

2. Personal communication with the artist, February 2012.

3. The work of several Inuit artists has been influenced by extended stays as children or adults in hospitals and TB sanitorims in southern Canada, in addition to the residential school experience.

4. Pannese and Ruben, 2012.

5. Price in Fitzhugh and Ward 2000: 70.

6. Rasmussen 1929.

7. Christensen in Fitzhugh and Ward 2000: 91–92.

8. ibid: 88.

9. Vesteinsson in Fitzhugh and Ward 2000: 164–165.

10. Jorgensen in Fitzhugh and Ward 2000: 77.

11. Wallace in Fitzhugh and Ward 2000: 208.

12. Schledermann in Fitzhugh and Ward 2000: 248–256.

13. Sutherland in Fitzhugh and Ward 2000: 238–247.

14. McGhee 1984: 374.

15. Pannese and Ruben, 2012.

16. Schaeff 2007: 358

17. www.web.med.harvard.edu/sites/RELEASES/html/12-13nweeia.html

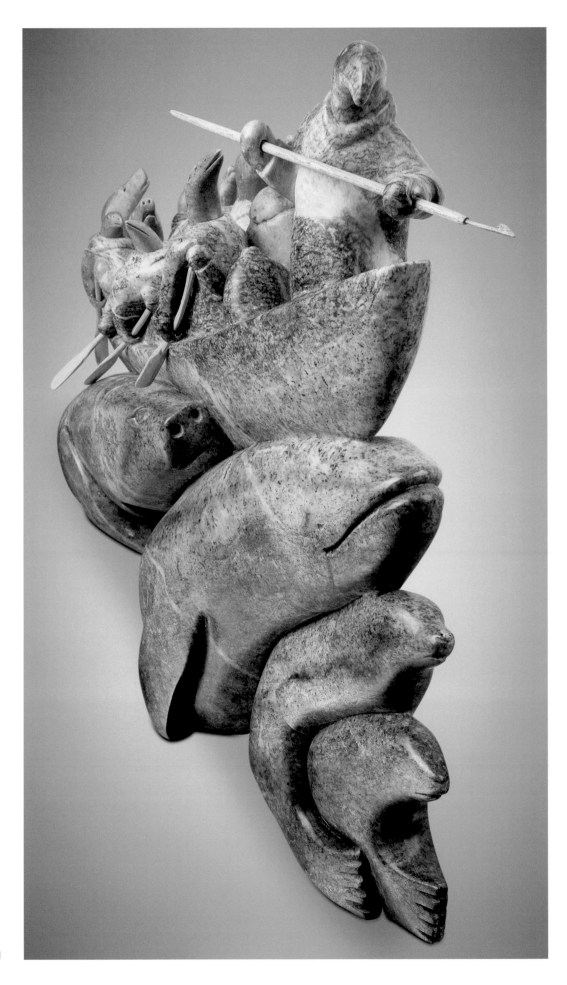

Another view of *Migration:*
Umiak with Spirit Figures, plate 21

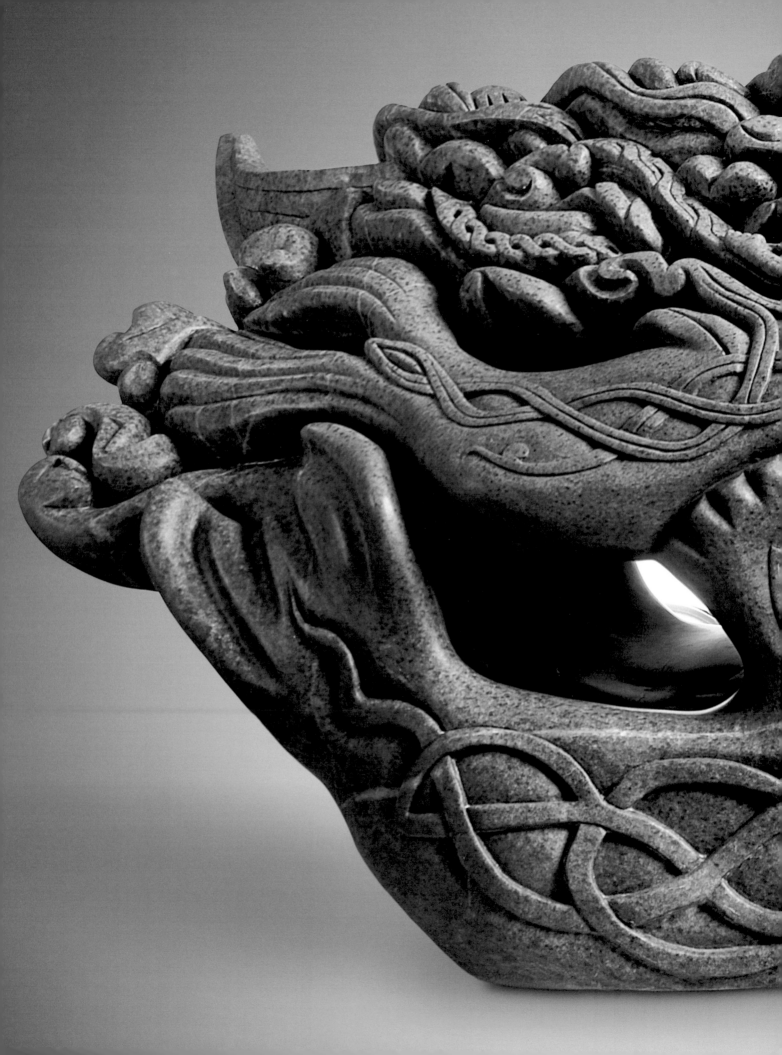

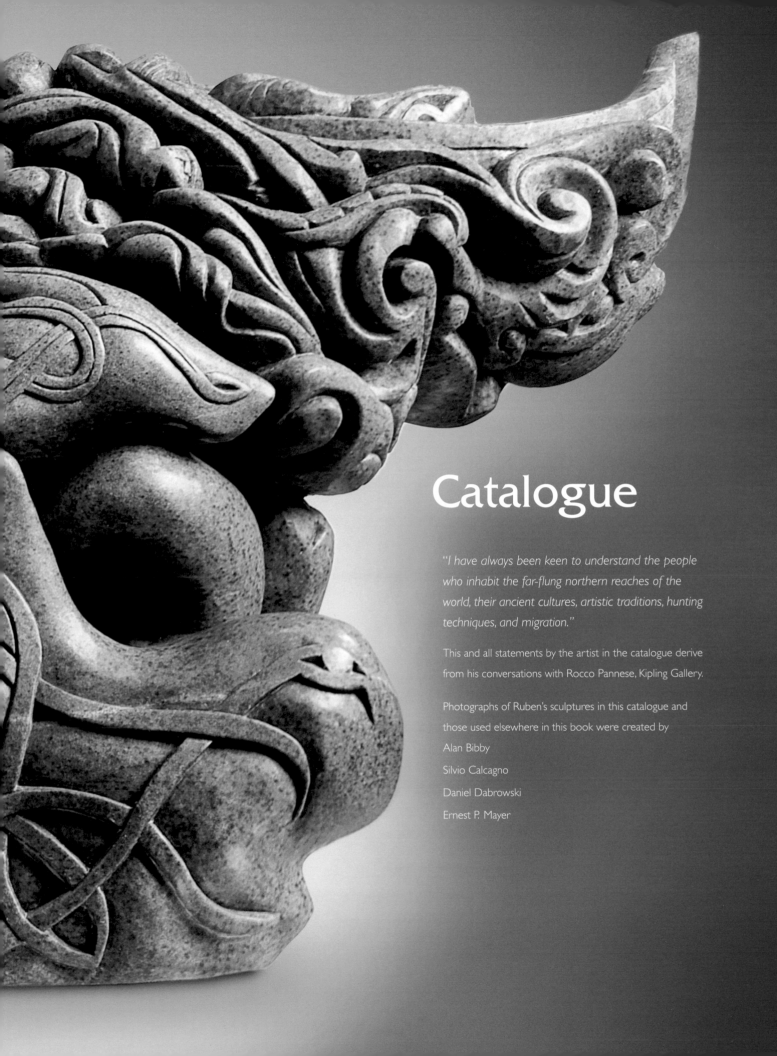

Catalogue

"I have always been keen to understand the people who inhabit the far-flung northern reaches of the world, their ancient cultures, artistic traditions, hunting techniques, and migration."

This and all statements by the artist in the catalogue derive from his conversations with Rocco Pannese, Kipling Gallery.

Photographs of Ruben's sculptures in this catalogue and those used elsewhere in this book were created by

Alan Bibby

Silvio Calcagno

Daniel Dabrowski

Ernest P. Mayer

1 Arctic Apocalypse

2009
Brazilian soapstone and alabaster
75 x 91.5 x 65 cm
Collection of Sheldon Inwentash and Lynn Factor

Climate change brought about by global warming is a serious threat to the North American Arctic, impacting ice conditions, migration patterns of animals and birds, and the hunting life of Inuit. *Arctic Apocalypse* highlights the artist's concern for northern communities confronting the potentially catastrophic effects of global warming.

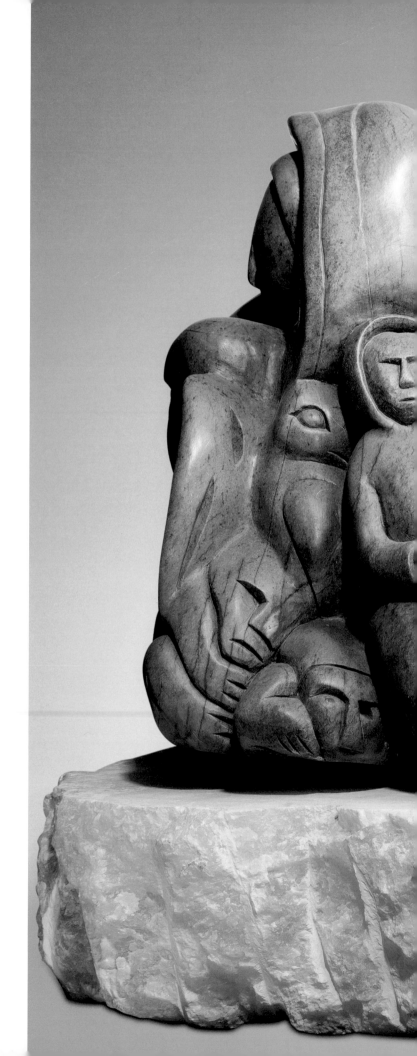

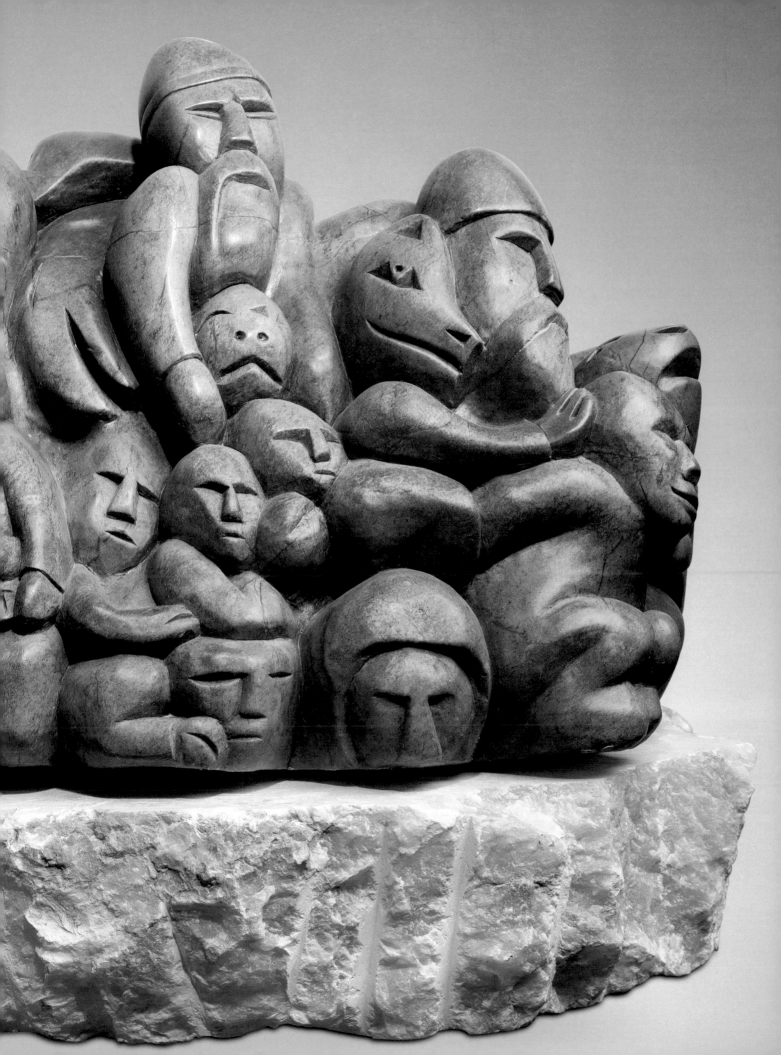

2 North Atlantic Saga

2011
Narwhal tusk: 211 cm
Brazilian soapstone base: 36 x 30 x 21 cm
Collection of Robert and Manuela Oliva

Using the ivory tusk of the narwhal, Ruben recounts the
history of Norse settlement in Iceland and Greenland. The
stone base depicts the stylized images of walrus, falcon,
and polar bear banded together by an intricate overlay of
Norse design elements. Following the natural spiral motion
of the tusk, carved figures illustrate men carrying swords;
their wives holding agricultural tools; a woman working in
the field; a blacksmith at his forge; and figures harvesting
the animals of land and sea. The top portion of the tusk
envisions a time of contact, trade, and collaborative hunting
between Norse settlers and the Thule people, ancestors
of Inuit.

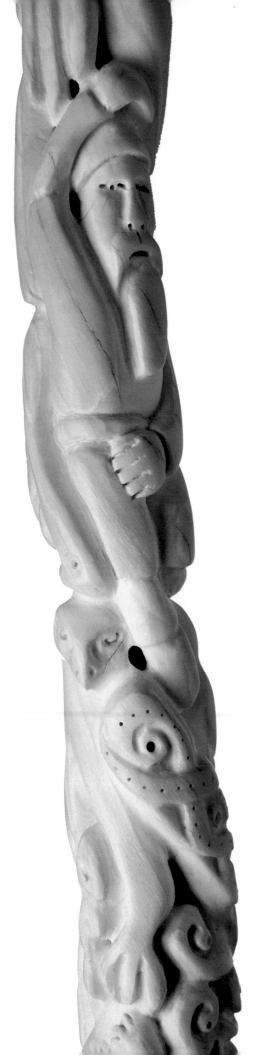

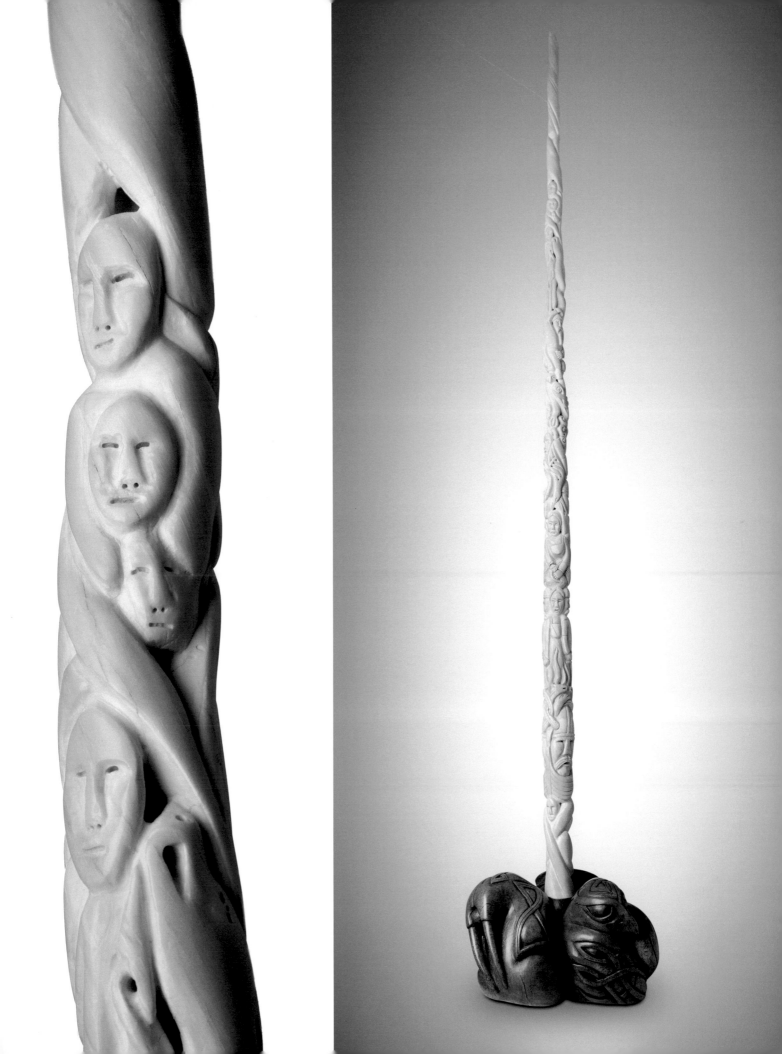

3 Odin, Shape Shifter

2012
Bronze 1/9
93 x 84.5 x 54 cm
Collection of the Platnick Family

The Norse god, Odin, was known as a seeker of wisdom and knowledge. He was a 'shape-shifter,' able to change his form at will, taking on the physical attributes of various birds and animals. This bronze sculpture represents Odin in a state of transformation assuming the shapes of bear, eagle, raven, loon, and other animals.

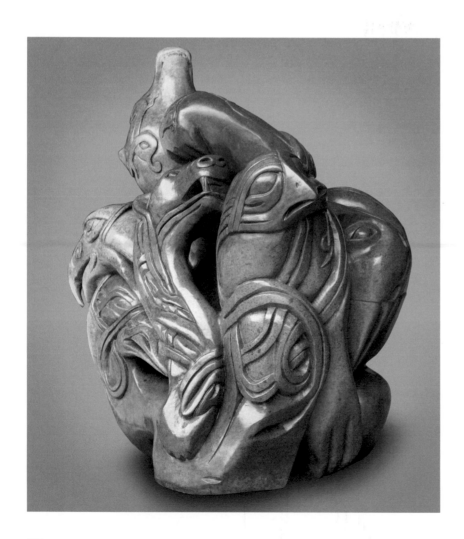

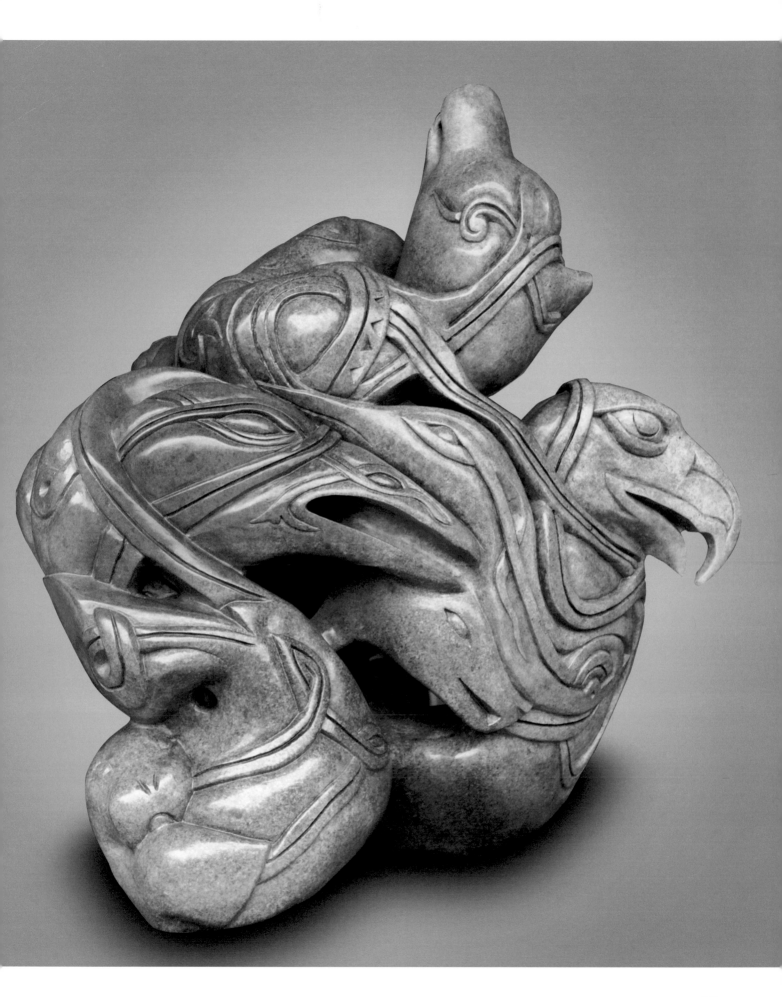

4 Odin's Story

2009
Brazilian soapstone
76.5 x 53 x 45 cm
Collection of Mark Beggs

In this sculpture, the artist portrays Odin with his sword, a symbol of his power as god of war. Odin is surrounded by the images of birds, animals, and spirits, whose shapes, knowledge, and capabilities he is able to assume at will.

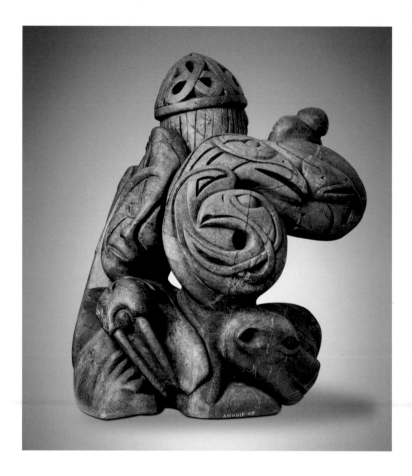

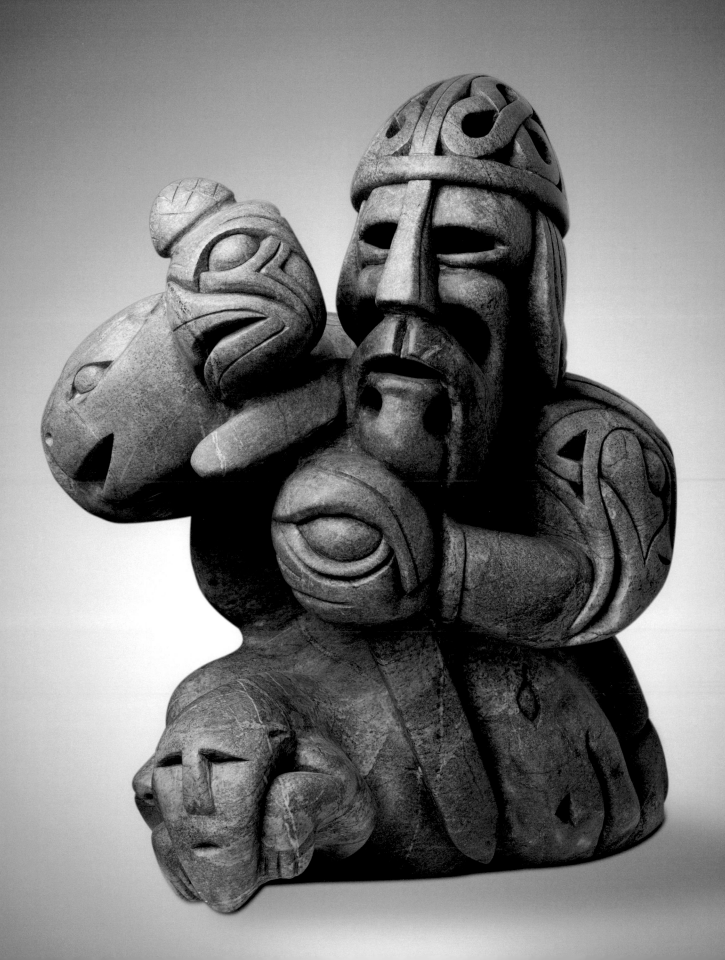

5 Odin

2008
Brazilian soapstone
56 x 37 x 20.5 cm
Collection of Richard and Marilyn Cooper

Setting out in search of land and resources, the
Norse carried with them their mythology and ancient
religion. This sculpture recalls the courageous
voyages of settler families who are accompanied
by their domestic animals, smithies, and household
goods. The protective image of Odin hovers above
them.

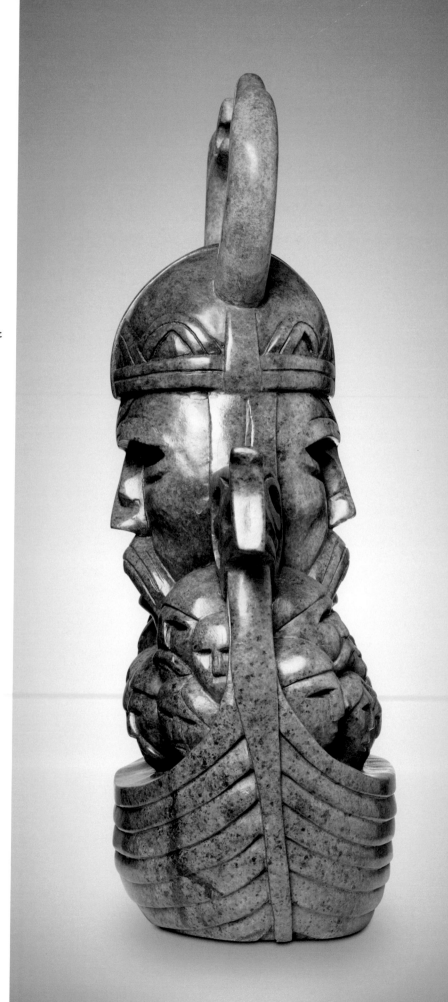

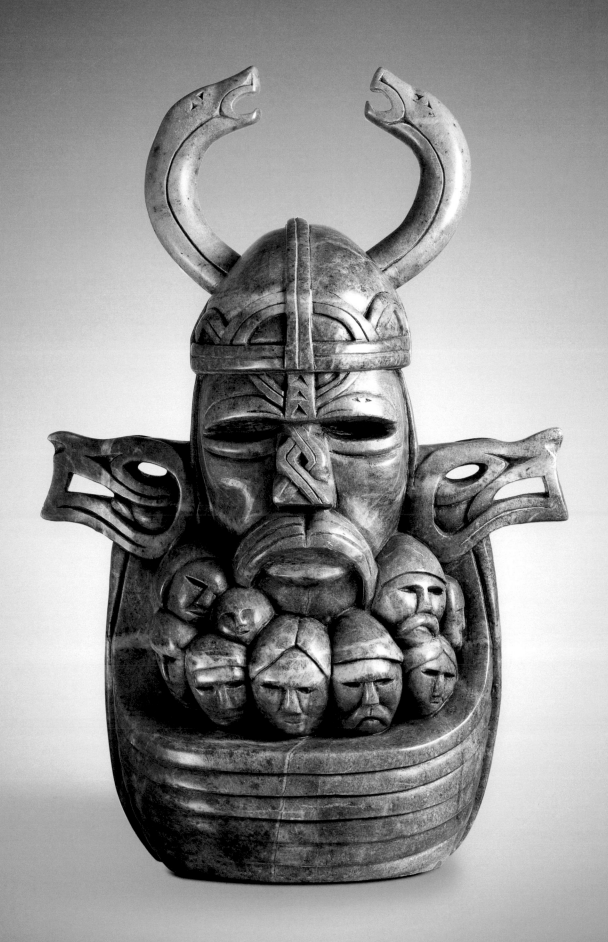

6 Thor, AD 900

2009
Bronze 1/9
81 x 58.5 x 46 cm
Collection of Nick and Elaine Tsimidis

Thor, son of Odin, was regarded as the god of thunder and protector of sea travelers, warriors, and adventurers. This sculpture, cast in bronze, shows Thor within the profile of the polar bear, the powerful guardian spirit respected across the North. Images of wolves, falcons, dragon heads, and mythological beasts of ancient Scandinavia highlight the opposite side of the sculpture.

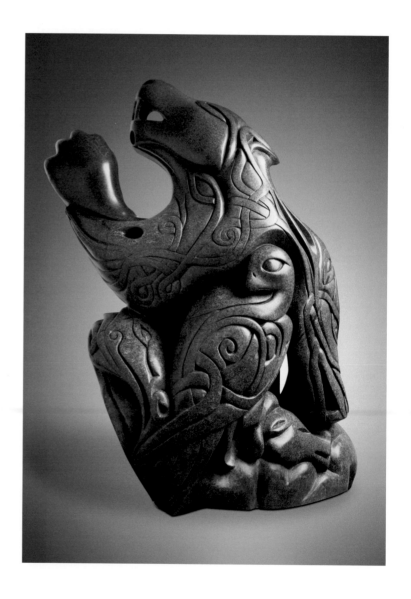

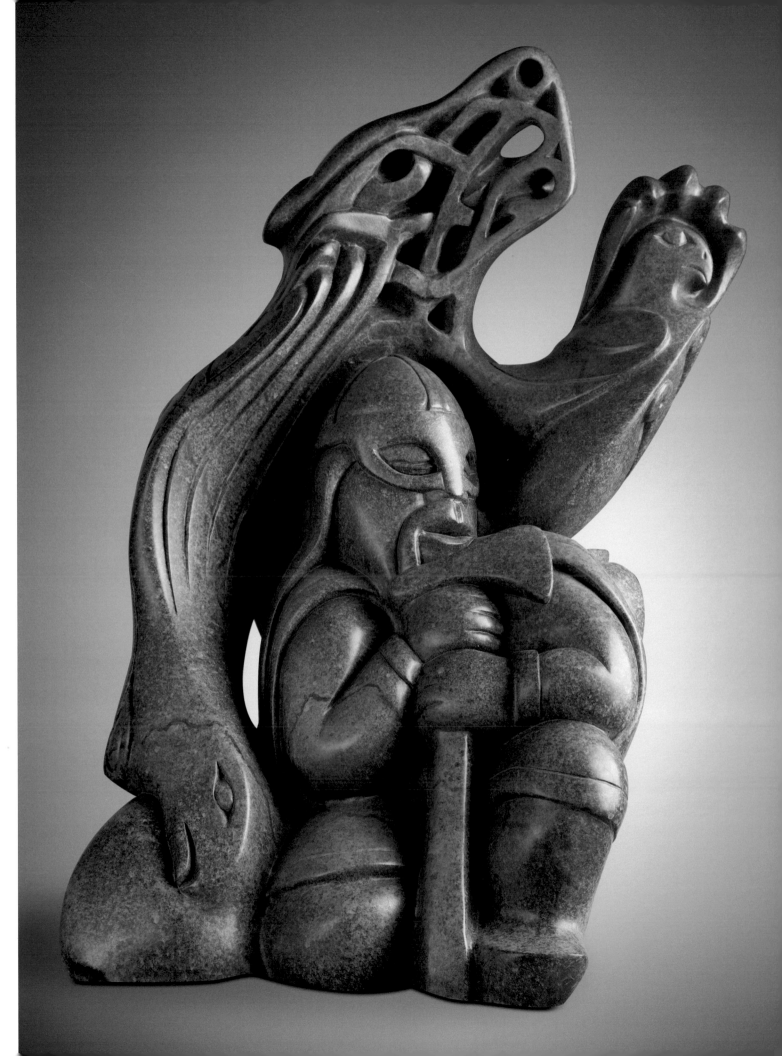

7 Into the New World

2011
Oregon soapstone, Brazilian soapstone
50 x 102 x 30.5 cm
Collection of PowerOne Capital Markets Ltd.

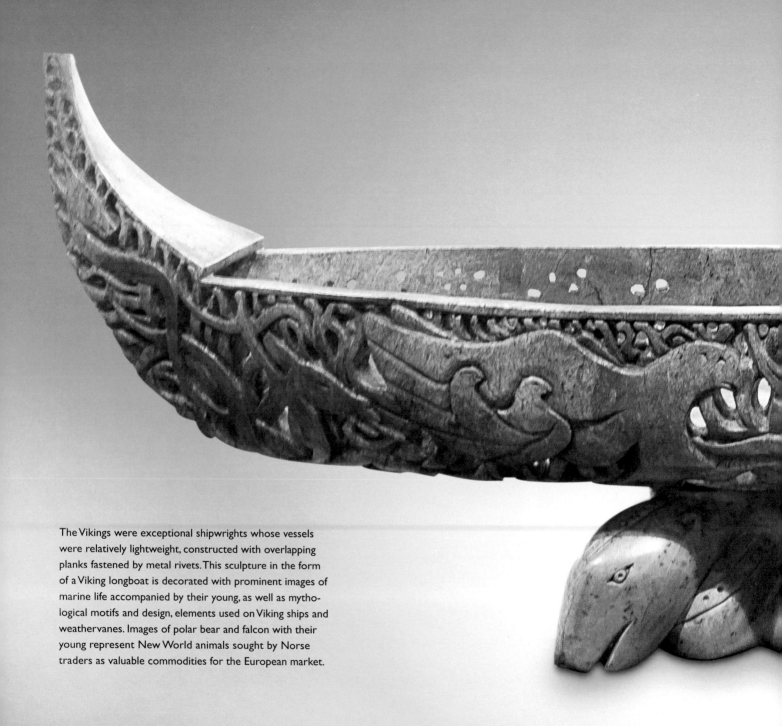

The Vikings were exceptional shipwrights whose vessels
were relatively lightweight, constructed with overlapping
planks fastened by metal rivets. This sculpture in the form
of a Viking longboat is decorated with prominent images of
marine life accompanied by their young, as well as mytho-
logical motifs and design, elements used on Viking ships and
weathervanes. Images of polar bear and falcon with their
young represent New World animals sought by Norse
traders as valuable commodities for the European market.

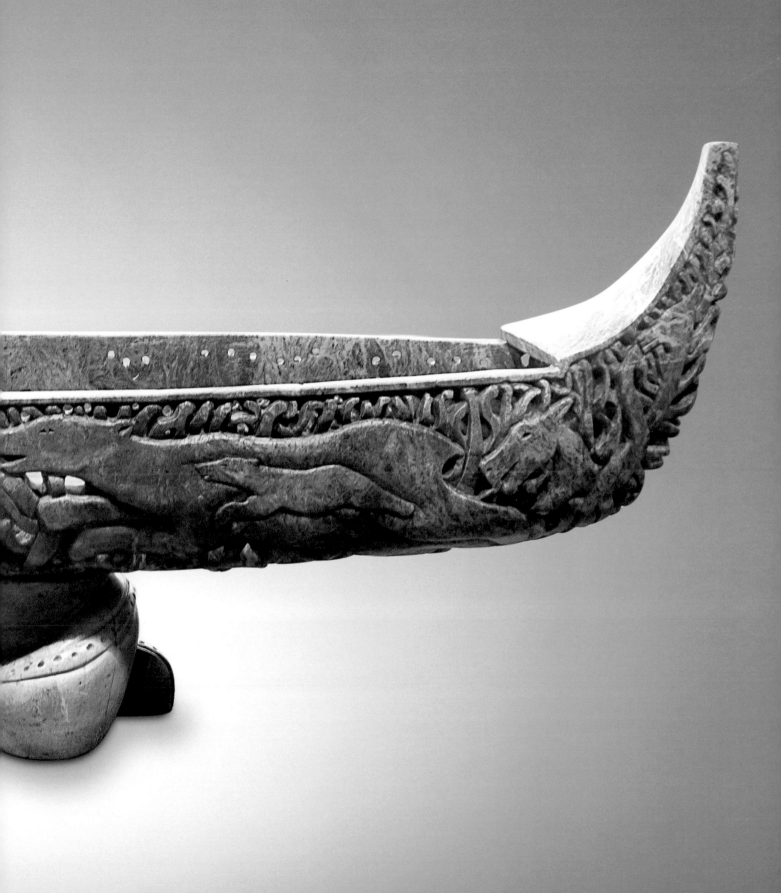

8 Born of Ice and Fire

2008
Brazilian soapstone
58 x 30 x 28 cm
Collection of Mark Beggs

The geothermal environment of Iceland—
a land of ice caps, glaciers, and active
volcanoes—allowed Norse settlers to
establish farms and coastal communities
in the late ninth century.

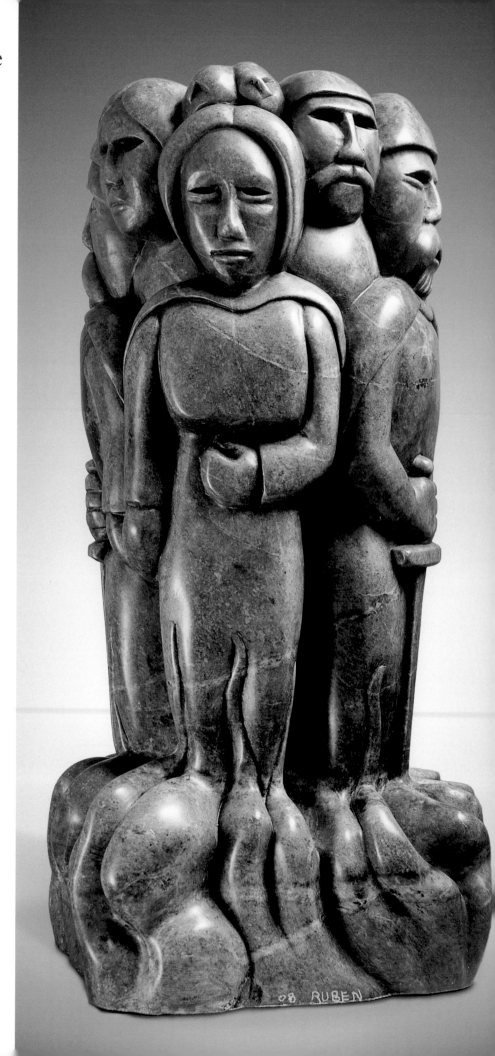

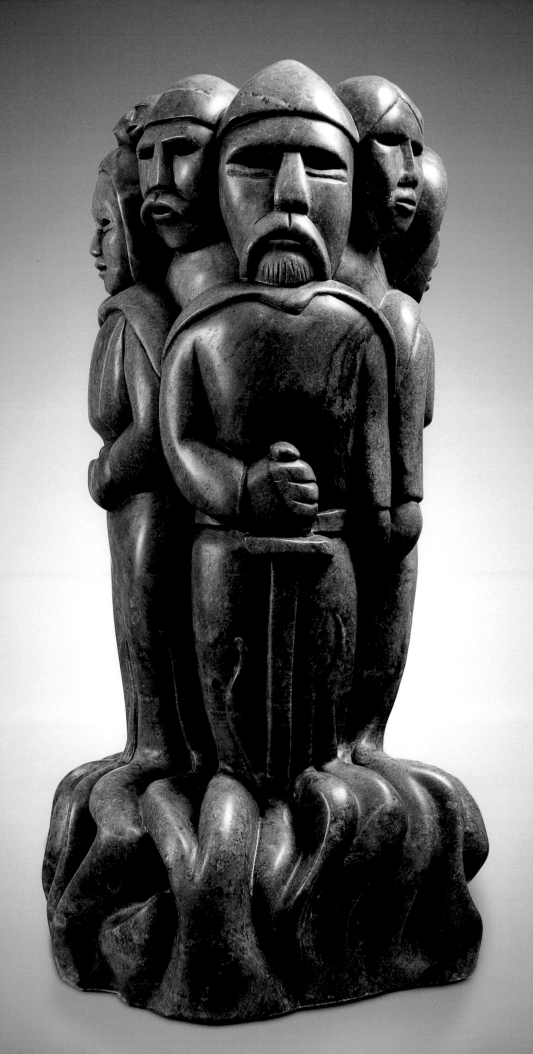

9 Shaman's Dream

2011
Bronze 1/9
78.5 x 36.5 x 51 cm
Private Collection, Toronto

"My mother told me that our people had always been shamans. We grew up with that understanding. When I chose to become an artist, I felt that the path I was given was to tell the shaman's story through our culture and spiritual traditions—to tell stories of things that matter."

Able to travel across land, sea, and sky with the aid of helping spirits, the Inuit shaman (*angakkuq*) was regarded as the primary mediator between the human and spirit worlds. Here the shaman is draped with a bear skin. Images of birds, animals, and spirits radiate from the face of Sedna, the Inuit guardian of sea animals, on the back of the sculpture.

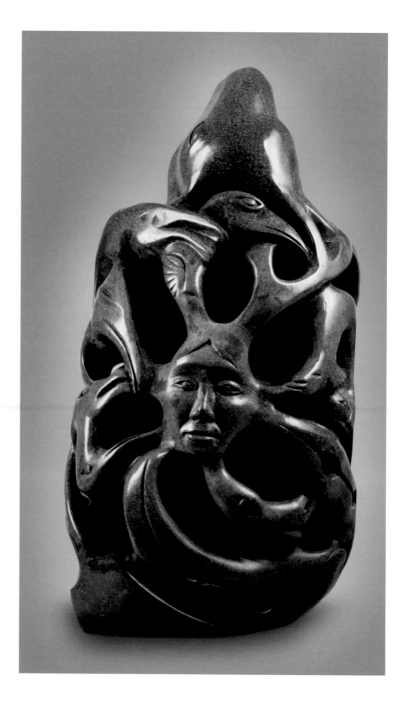

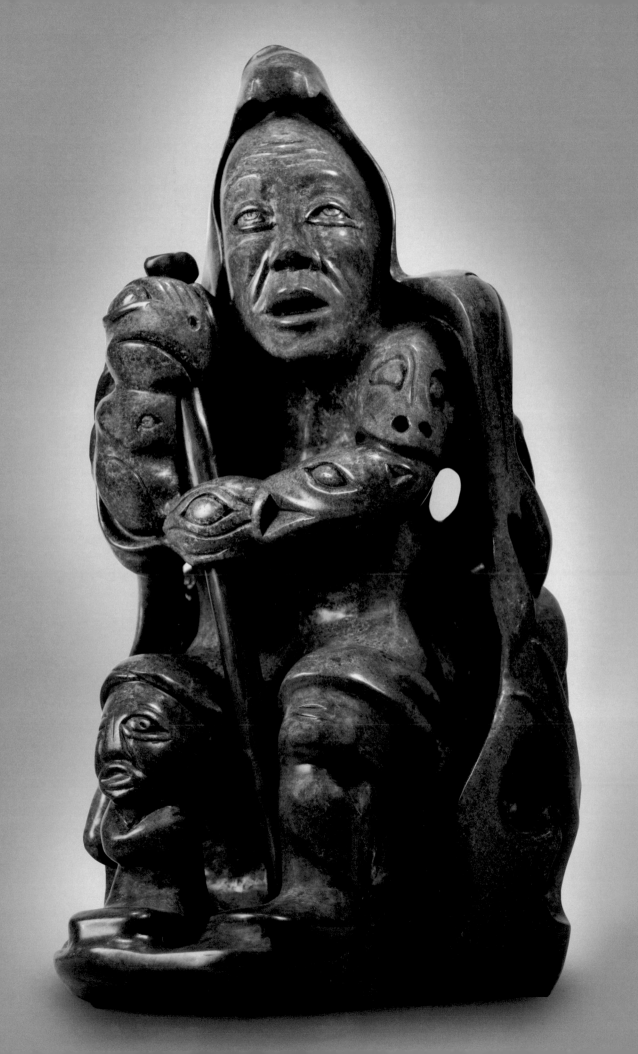

10 Study for Shaman's Dream II

2011
Brazilian soapstone
45 x 20.5 x 19.5 cm
Collection of Canadian Heritage Art Gallery

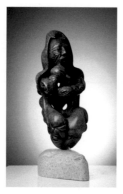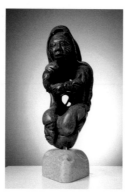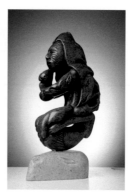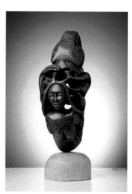

As a student at the Native Arts Center, University of
Alaska (Fairbanks), Ruben developed a talent and
appreciation for working in miniature. This small-scale
study for *Shaman's Dream* (plate 9) and the study for
Shaman's Message (plate 12) reveal the artist's
conceptual process.

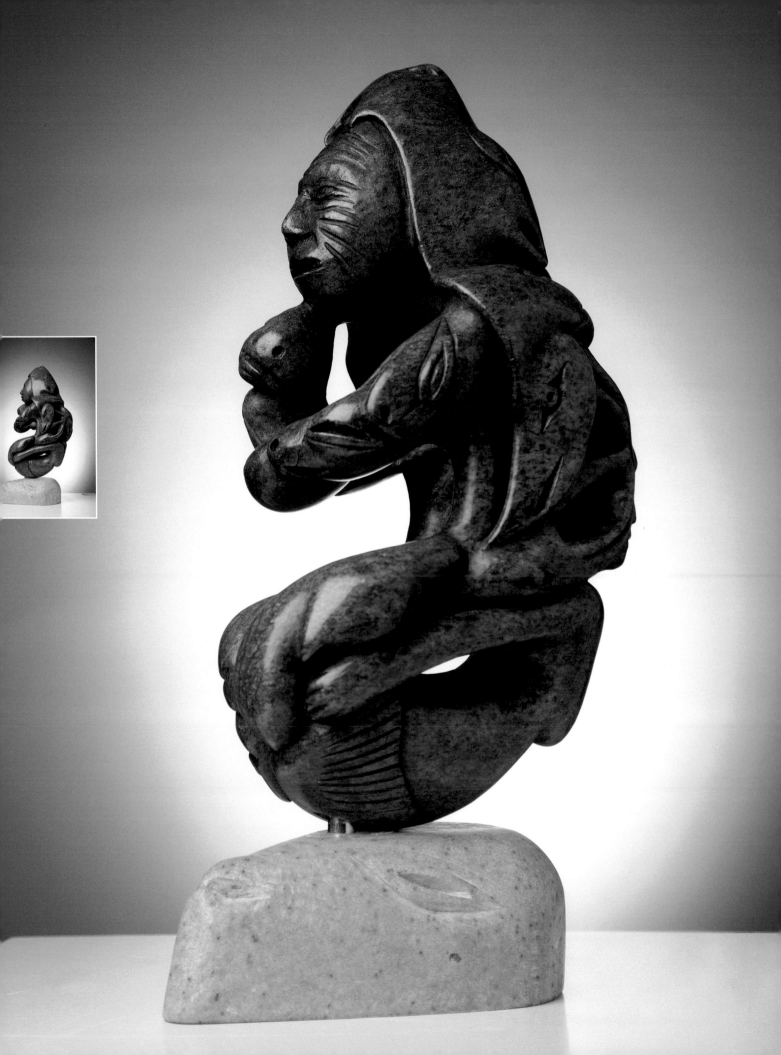

11 Study for Shaman's Dream III

2011
Brazilian soapstone
49 x 15.5 x 20.5 cm
Collection of Blain and Averil Caverly

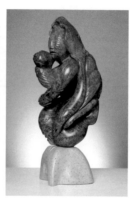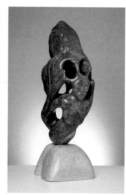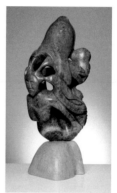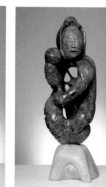

*"Throughout my childhood I had ... the most vivid of dreams,
dreams of being in other worldly places and meeting people and
being in the dream world."*

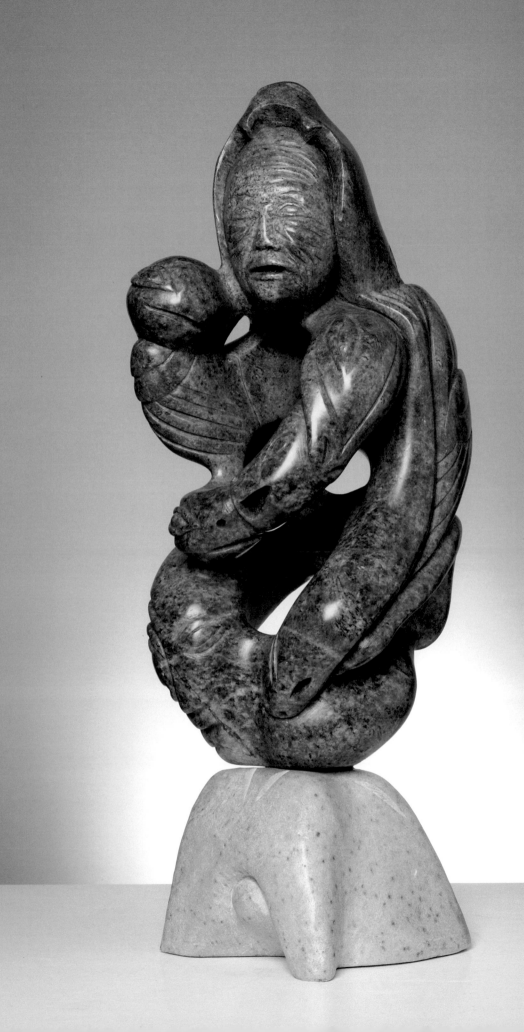

12 Study for Shaman's Message III

2011
Brazilian soapstone
44 x 20.5 x 25.5 cm
Collection of Maria Sugamosto

 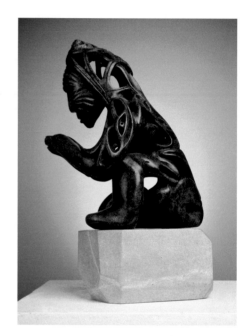

*"My mother was given initiations at an early age and they
became an integral part of her entire life. She was able to
integrate the best of her shamanic upbringing with the best
that Christianity had to offer to her life and circumstances."*

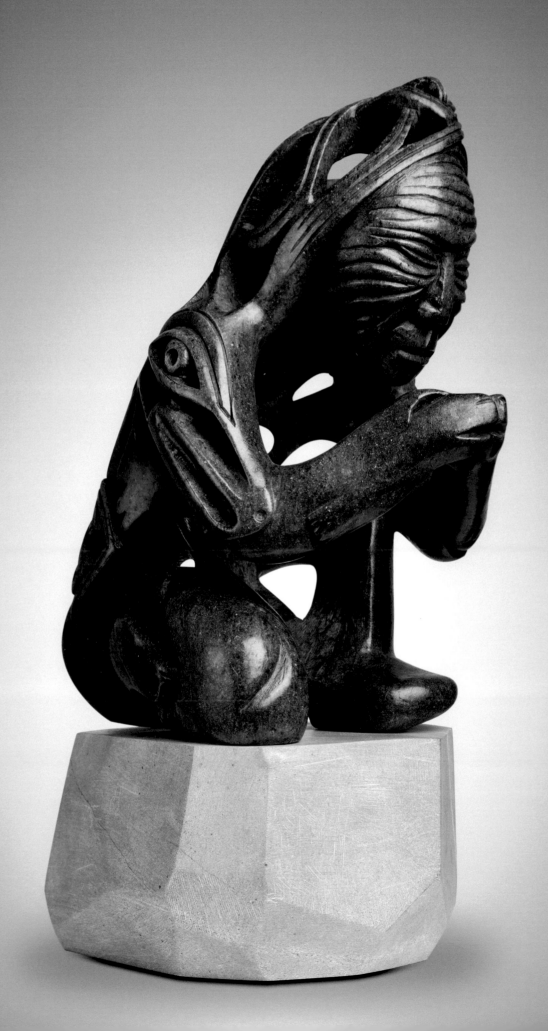

13 Water Bear

2010
Bronze 3/9
53 × 23 × 26 cm
Collection of Dr. and Mrs. J. Greenspan

Feared and respected for its strength and intelligence, the
polar bear (*nanuq*) is keenly regarded as a shaman's most
prominent helping spirit. In this sculpture, the artist envisions
the shaman embodied within his helping spirit.

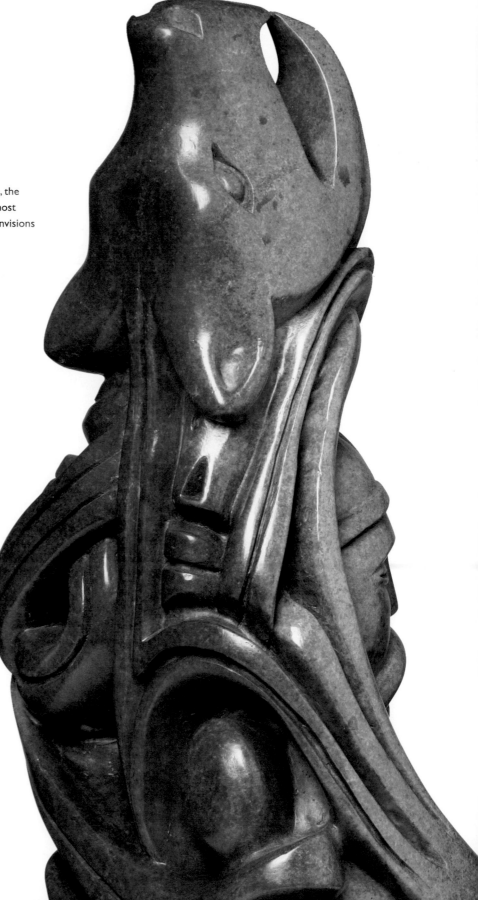

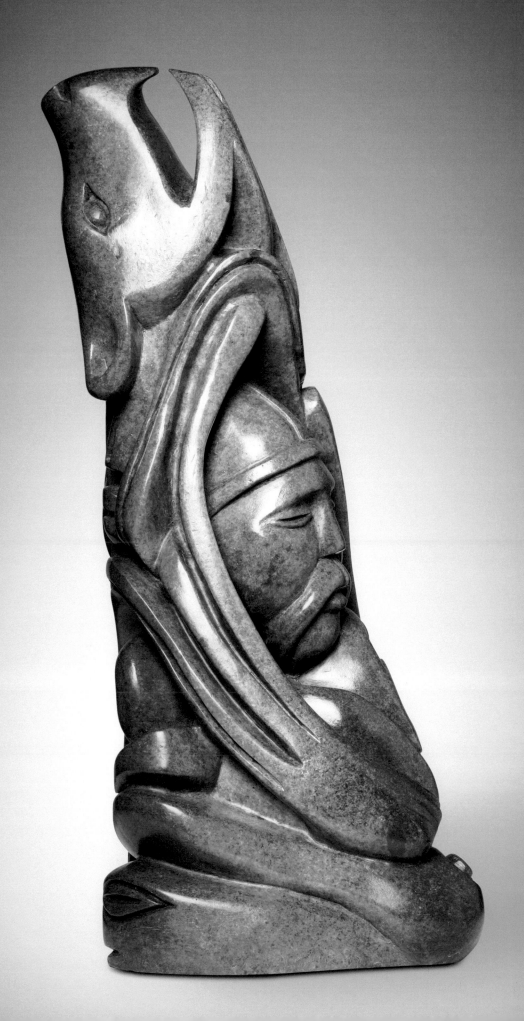

14 To Northwestern Shores

2008

Brazilian soapstone

61 x 101.5 x 53 cm

Collection of Troshan Inc.

Masterfully carved, this sculpture highlights the terrifying challenges faced by Norse adventurers, traders, and settler families who left the security of their homeland for the New World and reached the coast of Newfoundland around AD 1000.

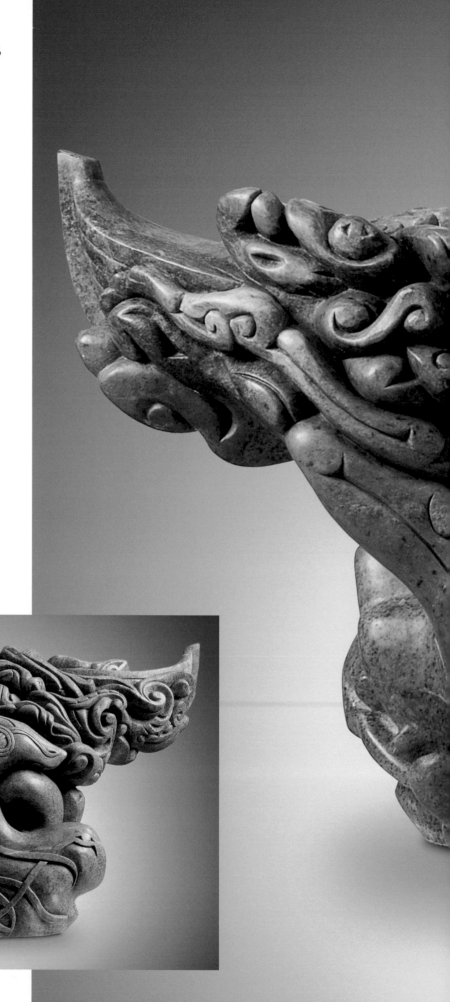

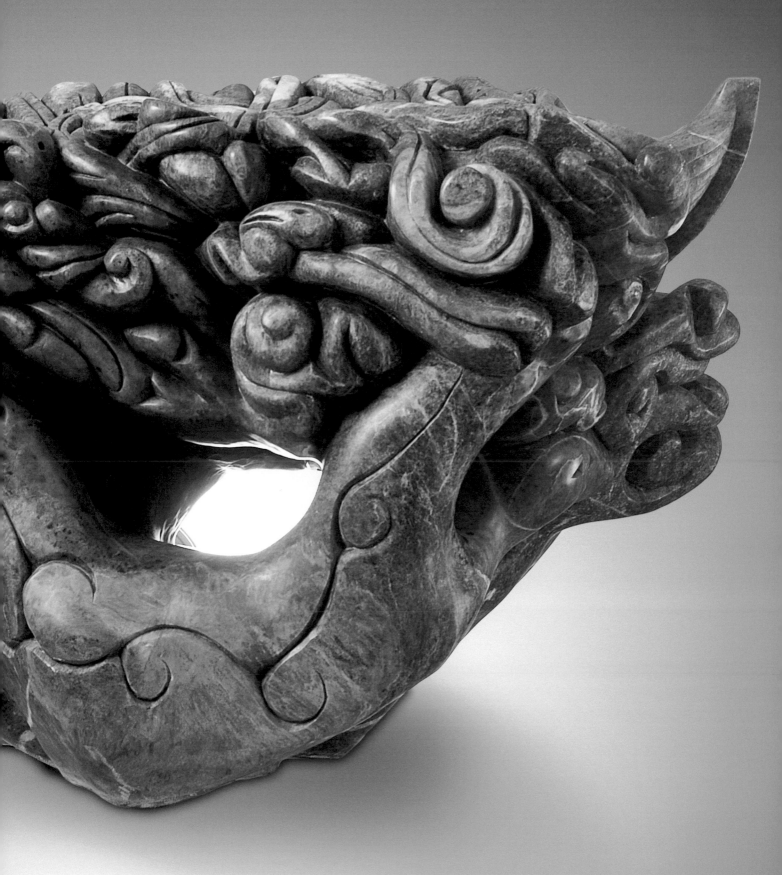

15 Celtic Monk: Keeper of Light

2007
Brazillian soapstone
88 x 39 x 30 cm
Collection of Larry Kubal

Irish monasteries and abbeys served as theological centers
as well as literary and artistic workshops. Renowned as
scribes and illustrators, Irish monks also ventured out as
evangelists to spread the Gospels. Here the artist recalls the
itinerant life of a Celtic monk, shown with his walking staff
and manuscripts in hand. Using the memory of his father's
face as a model, the sculptor depicts an aged figure, a symbol
of wisdom and knowledge.

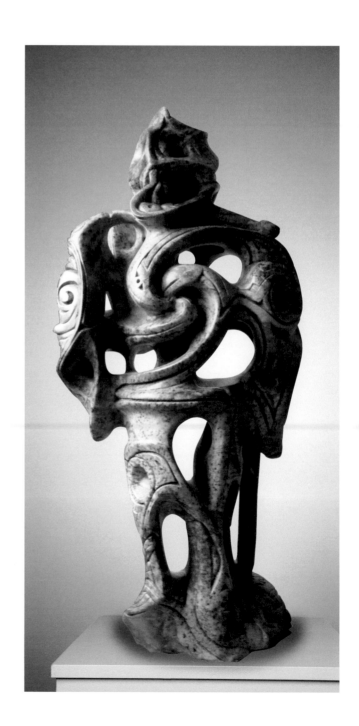

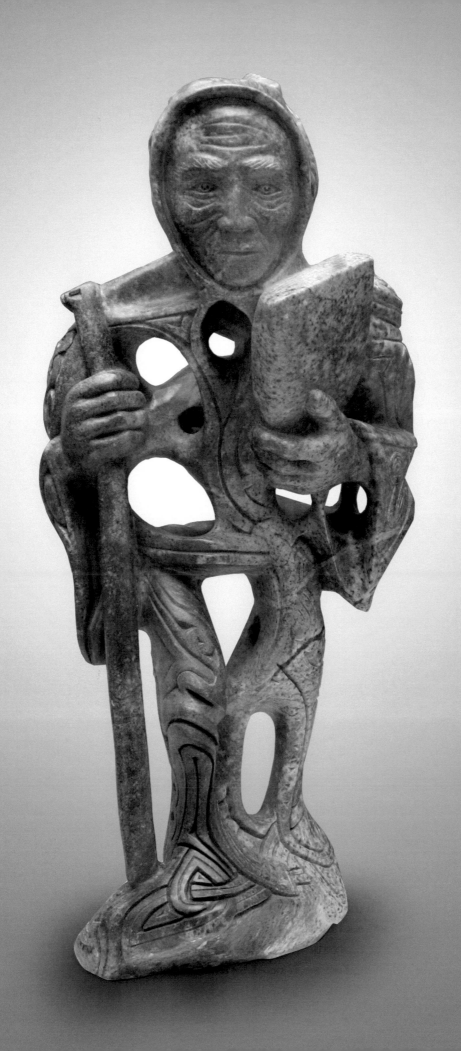

16 Inuvialuit: Inuit Way of Life

2011
Ivory narwhal tusk
Brazilian soapstone base
Tusk: 188 cm
Base: 46 x 42 x 20 cm
Collection of Kipling Gallery, Ontario

The sculpture's soapstone base portrays a panoply of languid figures of northern animals and mythological beings. Figures on the narwhal tusk recall the exploits of Inuit shamans: a shaman braiding Sedna's hair; another reviving a young boy; and Kublualuk, a powerful Inuvialuit shaman, being lifted into the sky by a giant gyrfalcon. Carved images of land and sea creatures illustrate the return of life to the land and the historical resurgence of the Inuvialuit following the tragic epidemics and loss of life in the early twentieth century.

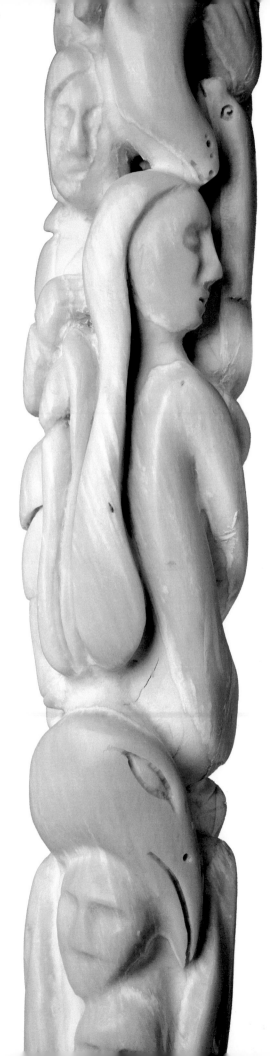

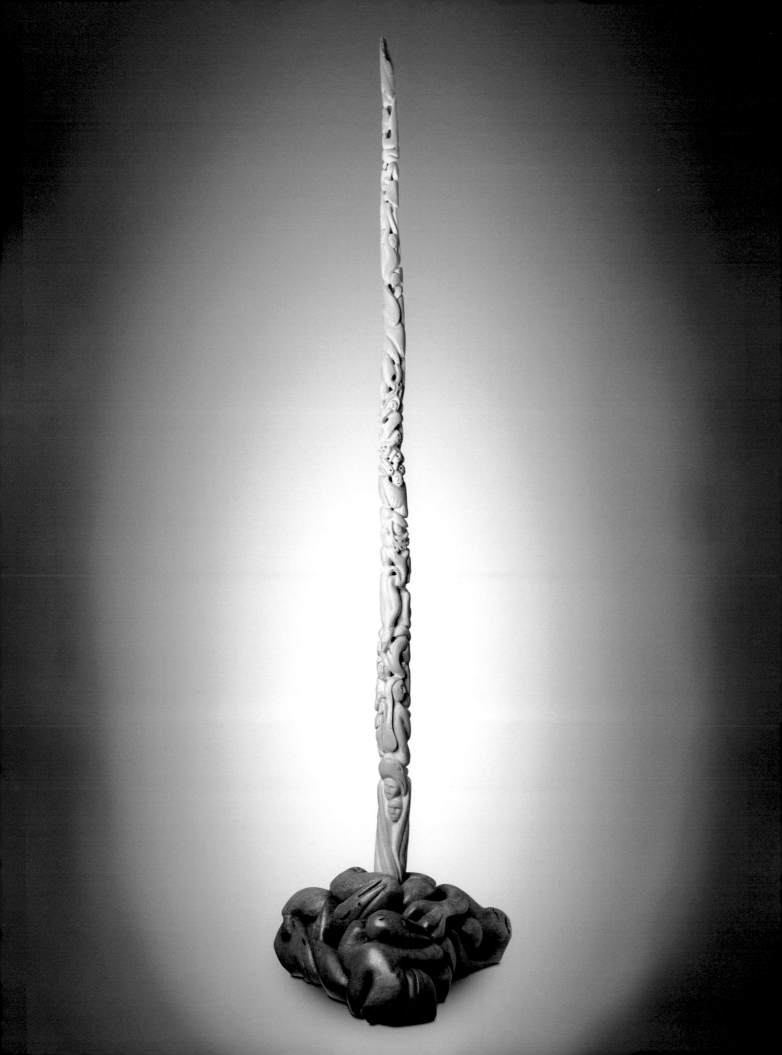

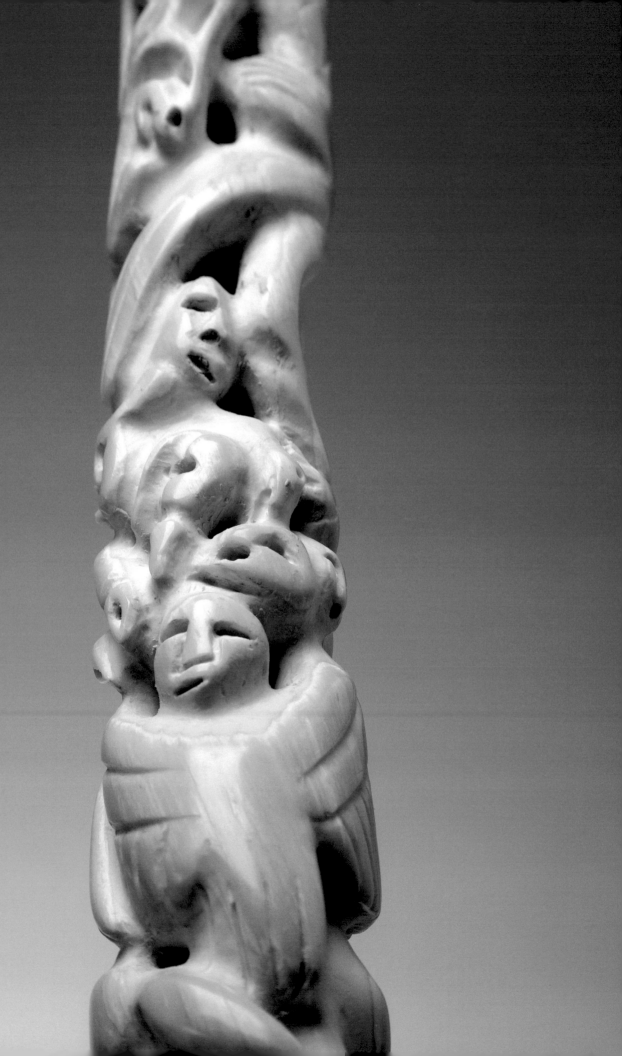

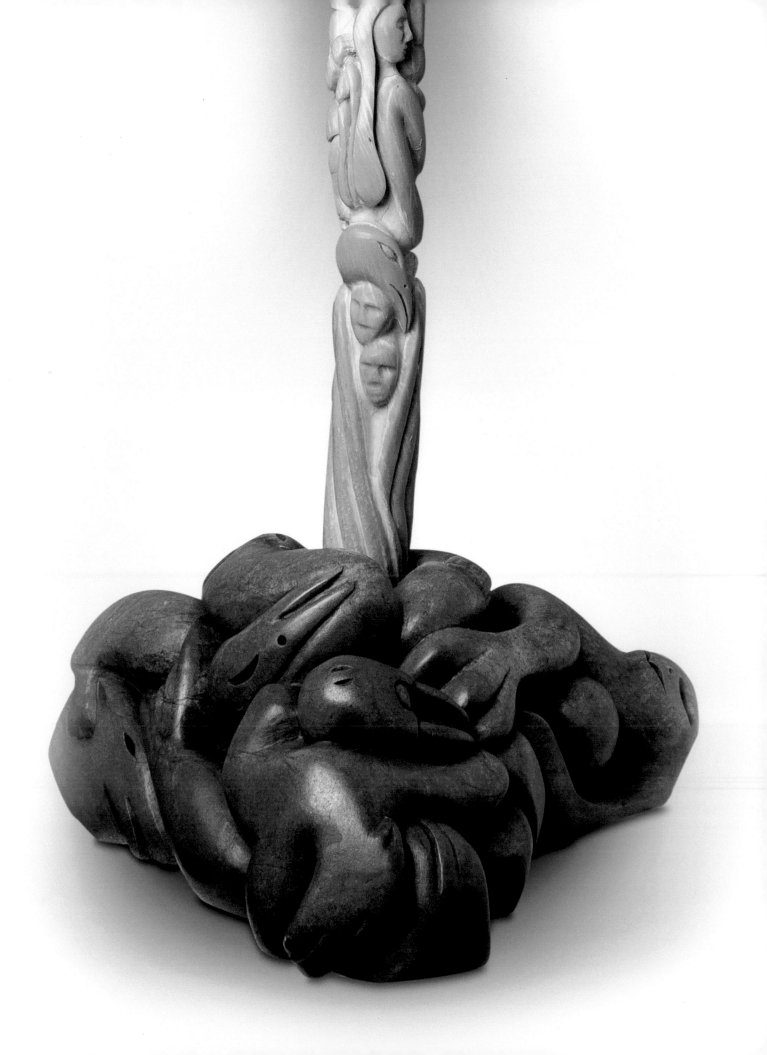

17 Sedna: Life Out of Balance

2006
Brazilian soapstone
84 x 58.5 x 28 cm
Collection of Peter and Belinda Priede

This sculpture expresses the artist's abiding concern for climate change and its far-ranging environmental and social consequences across the Arctic. *Sedna: Life Out of Balance* illustrates a period of climate change with cooler temperatures that began in the twelfth century, a change in climate that eventually lead to the abandonment of Norse settlements in Greenland. This sculpture portrays Sedna, the Inuit sea goddess, whose hair and limbs become the sea ice supporting Inuit and Norse families.

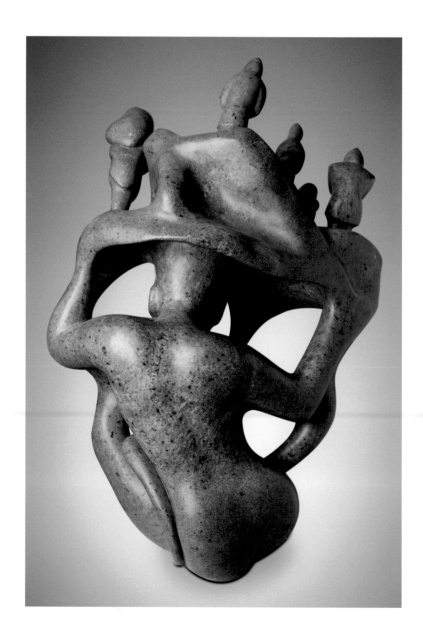

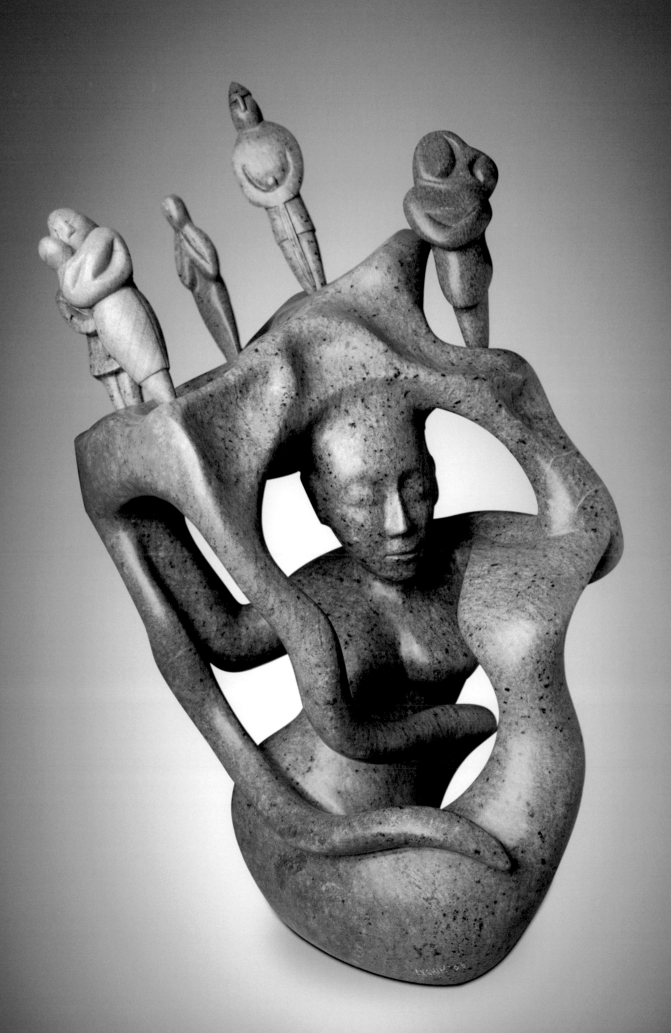

18 Breaking Tradition

1999
Brazilian soapstone
41.2 x 84.5 x 27.7 cm
Collection of Samuel and Esther Sarick

An *umiak* is a large open boat constructed with a
wooden or whalebone frame and fitted with a sewn
cover of walrus or seal hides. Developed by the Thule
people, ancestors of the Inuit, the *umiak* was used for
whale-hunting and to transport families and goods
from camp to camp. For Ruben, the *umiak* often serves
as a metaphor for Inuit community. In this sculpture,
the sudden appearance of Sedna splits apart the *umiak*,
casting its spirit crew overboard, signifying a break with
the spiritual traditions of the past.

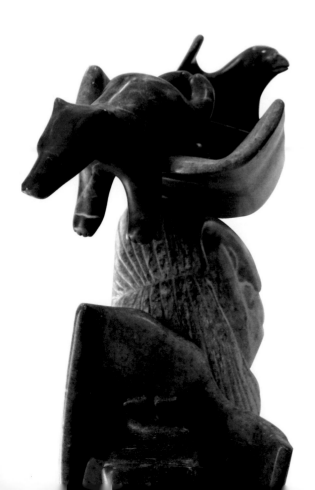

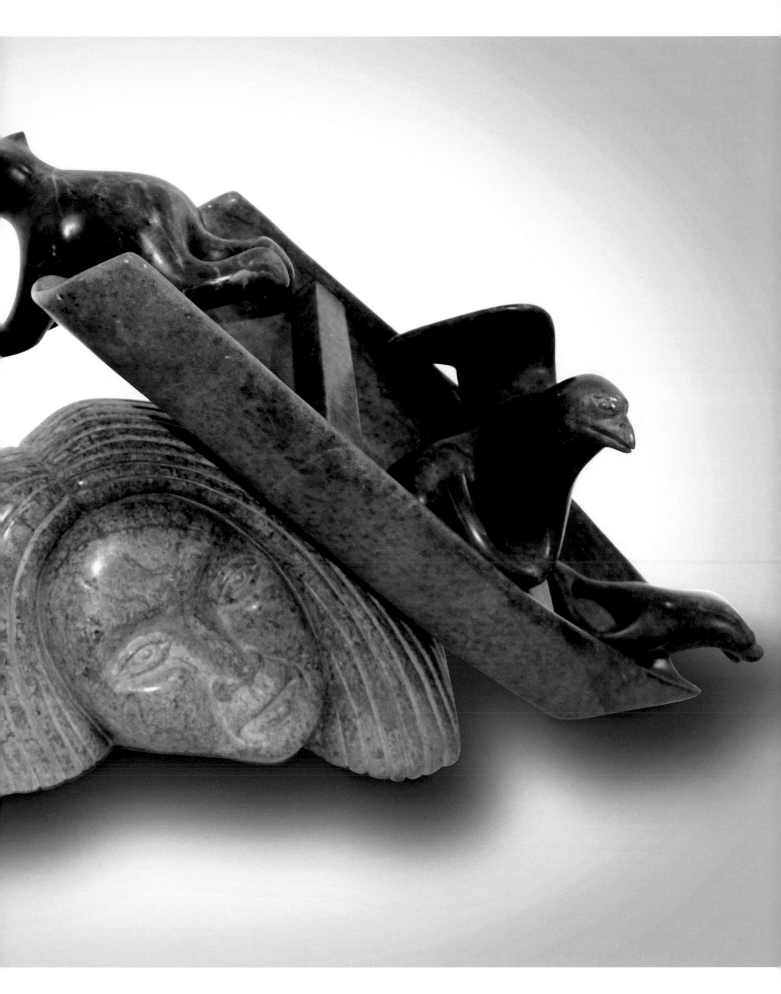

19 Into the Sunset

1999
Brazilian soapstone
31.7 x 89 x 22 cm
Collection of the Winnipeg Art Gallery,
Gift of Samuel and Esther Sarick

Here, the *umiak* carries a crew of human and
transformed figures. The title suggests a passing
of traditional ways and practices.

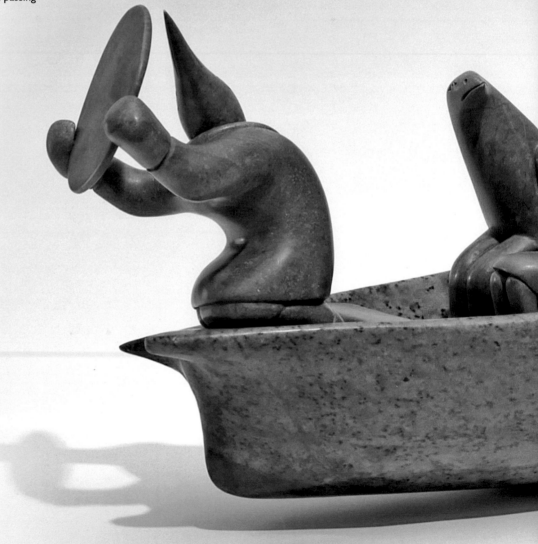

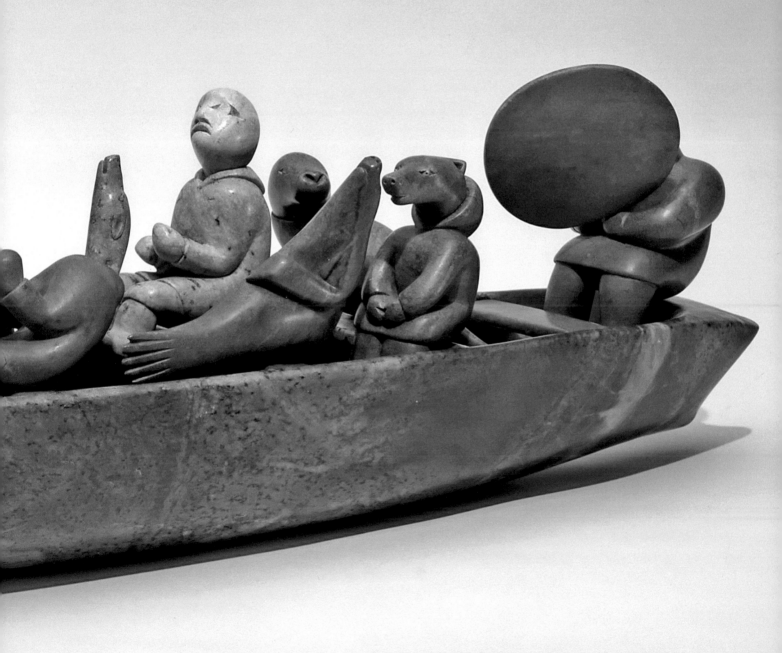

20 Silent Drum: Death of the Shaman

2001
Brazilian soapstone
28.5 x 34.5 x 79 cm
Collection of the Winnipeg Art Gallery,
Gift of Samuel and Esther Sarick

The tradition of shamanism remains a strong cultural memory
for Inuit, recounted in oral tradition, family stories, and art. The
shaman is portrayed at his final resting place, accompanied by
his drum (*qilaut*), lamp (*qudlik*), and other belongings—objects
intended for use in the afterlife. The title of the sculpture
suggests the loss of the *angakkuq's* spiritual power in the wake
of missionary teaching and the adoption of Christianity across
the Arctic.

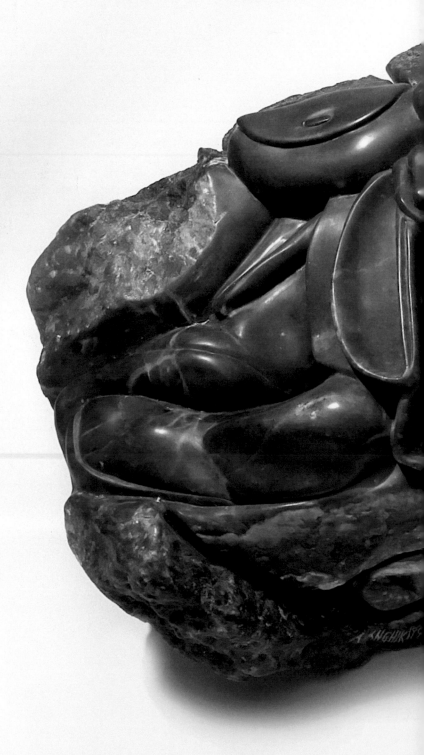

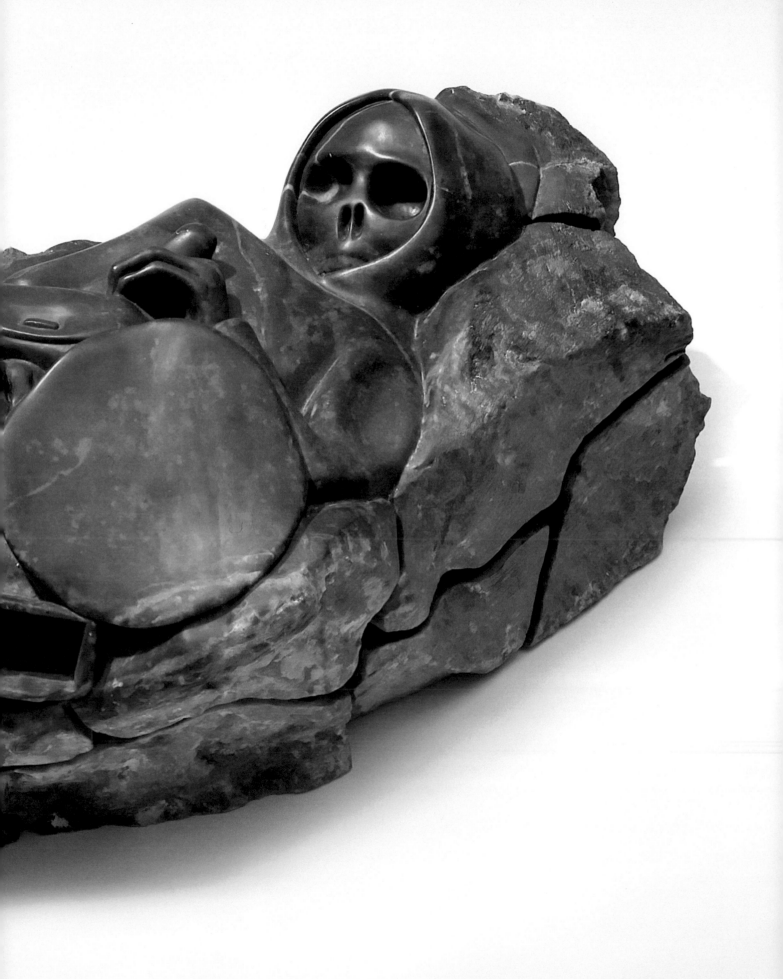

21 Migration: Umiak with Spirit Figures

2008
Brazilian soapstone, cedar, iron
63.5 x 93 x 25 cm
Collection of Sprott Asset Management

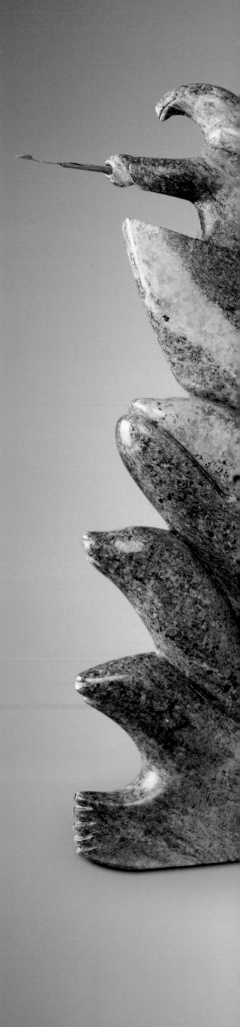

"My parents' influences still have a potent impact on my life, both on a personal and artistic level. They felt that Inuit beliefs were based on the interaction between humans and nature and were vital for the survival and preservation of their nomadic way of life. They have been the pathway to my past and the light to my future."

Although few Inuit lead a fully nomadic life today, seasonal activities still structure traditional life. This cycle of seasonal journeys is evoked in *Migration* with its crew of spirit figures filling an *umiak* that is supported and guided by abundant sea life below.

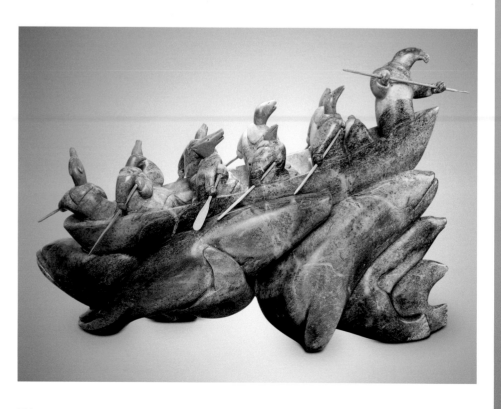

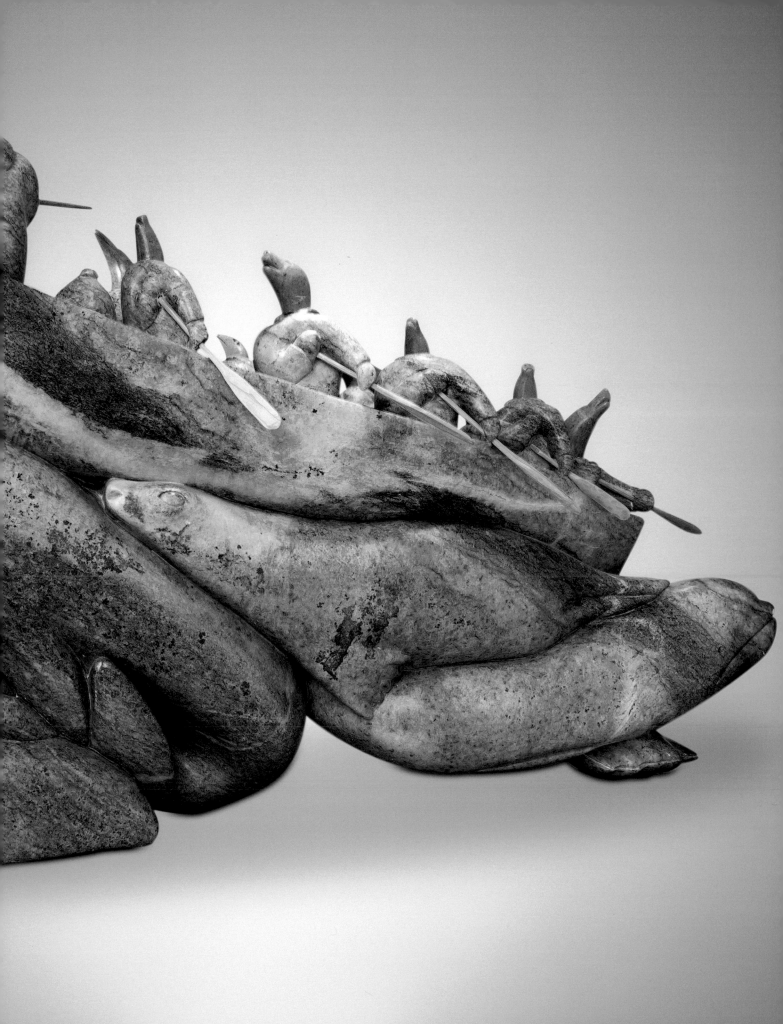

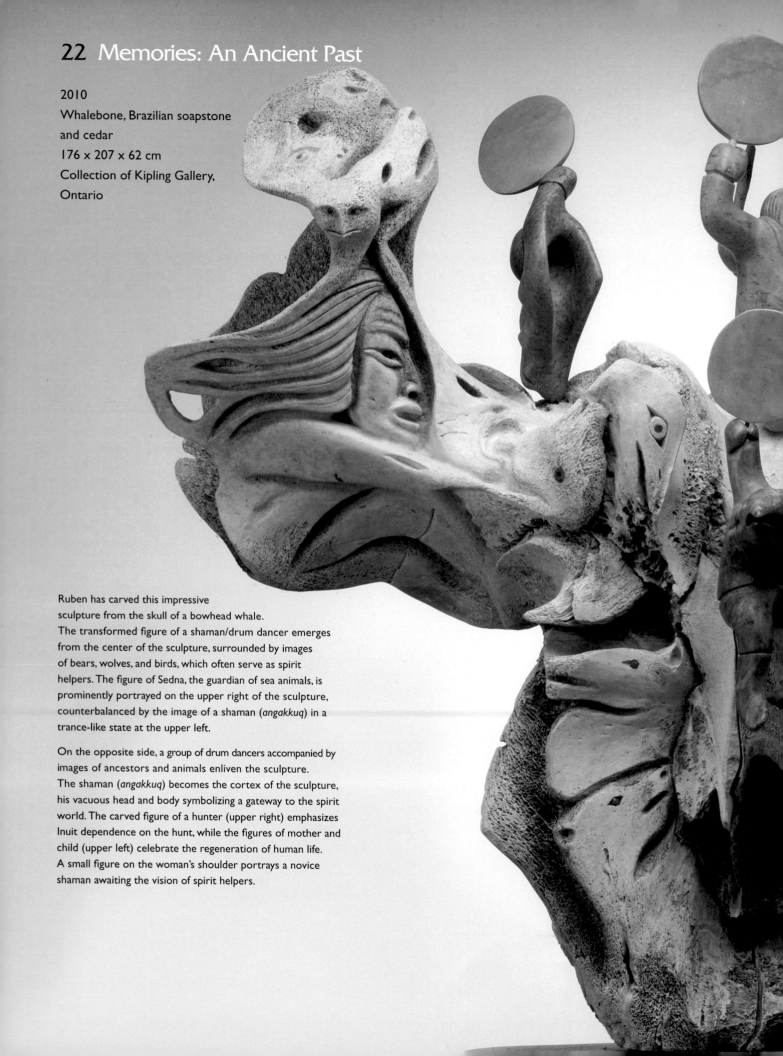

22 Memories: An Ancient Past

2010
Whalebone, Brazilian soapstone
and cedar
176 x 207 x 62 cm
Collection of Kipling Gallery,
Ontario

Ruben has carved this impressive
sculpture from the skull of a bowhead whale.
The transformed figure of a shaman/drum dancer emerges
from the center of the sculpture, surrounded by images
of bears, wolves, and birds, which often serve as spirit
helpers. The figure of Sedna, the guardian of sea animals, is
prominently portrayed on the upper right of the sculpture,
counterbalanced by the image of a shaman (*angakkuq*) in a
trance-like state at the upper left.

On the opposite side, a group of drum dancers accompanied by
images of ancestors and animals enliven the sculpture.
The shaman (*angakkuq*) becomes the cortex of the sculpture,
his vacuous head and body symbolizing a gateway to the spirit
world. The carved figure of a hunter (upper right) emphasizes
Inuit dependence on the hunt, while the figures of mother and
child (upper left) celebrate the regeneration of human life.
A small figure on the woman's shoulder portrays a novice
shaman awaiting the vision of spirit helpers.

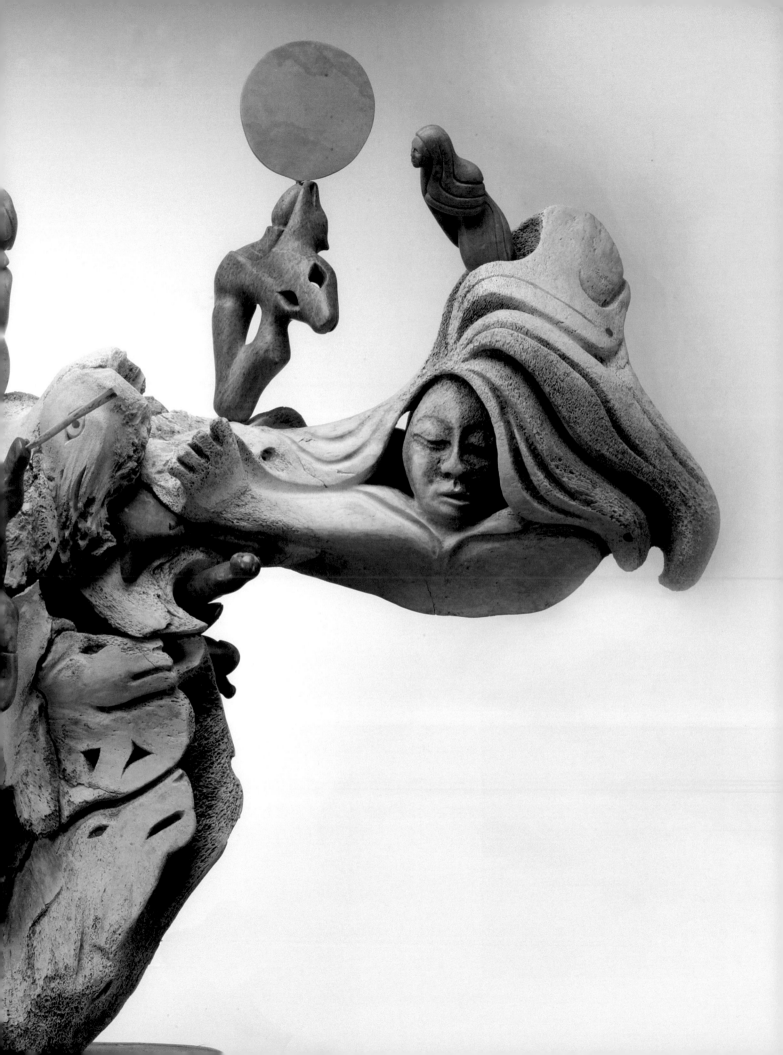

23 Hunters' Journey

2011
Brazilian soapstone
58 x 103 x 28 cm
Collection of Canadian Heritage Art Gallery

The Inuit families who settled in the Beaufort Sea and Mackenzie Delta region shared the maritime hunting traditions of Alaska's Bering Sea culture. The *umialik*, who was responsible for building the boat and training the crew to hunt beluga and bowhead whales, wears a raven's crest hat, a symbol of spiritual power. Through this sculpture Ruben celebrates the whale-hunting culture of his ancestors, the Inuvialuit. The figure of Sedna, the sea goddess who provides her bounty to deserving hunters, is portrayed beneath the boat, supporting and guiding the *umiak* and its crew.

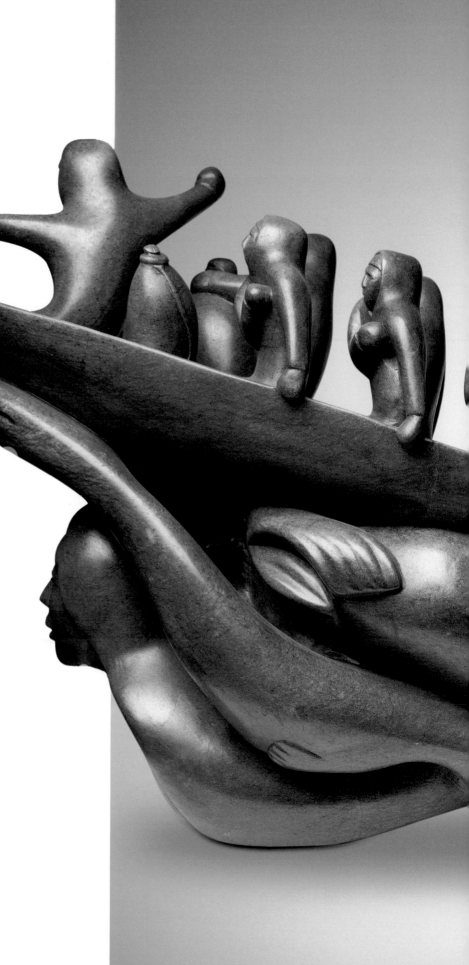

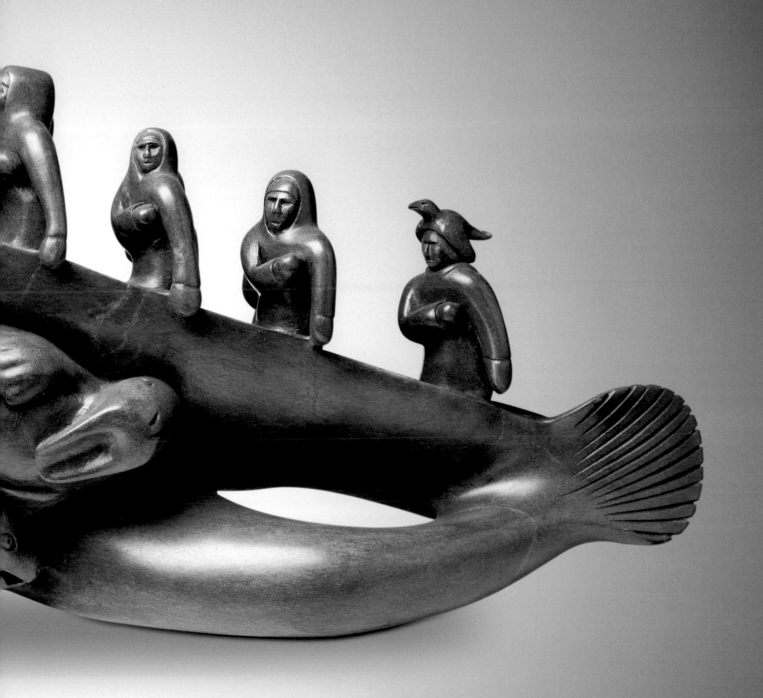

"I feel that I have found a place for myself within the arts community, because I have come to a time and place in my own life where I am comfortable with who I am and how I do what I do. I honour the memory of my parents, Bill and Bertha Ruben for the cultural tradition and spiritual values that they left me. I see the full impact and potential in the things that I do, leave no borders in what I feel I can do as an artist. I feel that my artistic life has just begun."

Exhibition History

Solo Exhibitions

2012 Hazelton Fine Art Gallery, Toronto, ON

2010 Abraham Anghik Ruben: Shaman's Dreams, Art Gallery of Mississauga, Mississauga, ON

2009 Abraham Anghik Ruben, Kipling Gallery, Woodbridge, ON

2008 *Abraham Anghik Ruben: Myths, Stories, Legends*, Kipling Gallery, Woodbridge, ON

2005 *Iceland 1000 AD*, Mayberry Gallery, Winnipeg, MB

2003 *The Art of Abraham Anghik Ruben*, Appleton Galleries, Vancouver, BC

2001 *Abraham Anghik Ruben*, The Winnipeg Art Gallery, Winnipeg, MB

2000 Paige's Art Gallery, Ketchum, Idaho

2001 Paige's Art Gallery, Ketchum, Idaho

2002 Paige's Art Gallery, Ketchum, Idaho

1998 Maslak–McLeod Gallery, Santa Fe, New Mexico

1994 *Abraham Anghik: Works in Bronze,* The Isaacs/Innuit Gallery, Toronto, ON

1991 *"Spirit of My People:" Sculptures by Abraham Anghik*, The Alaska Shop, New York, NY

1981 Images for a Canadian Heritage, Vancouver, BC

1980 *Abraham Anghik – New Sculptures,* The Pollock Gallery, Toronto, ON

1980 Bayard Gallery, New York, NY

1979 The Pollock Gallery, Toronto, ON

1978 The Pollock Gallery, Toronto, ON

1977 The Pollock Gallery, Toronto, ON

Two-Person Exhibitions

2012 *New Work by Ron Senungetuk and Abraham Anghik Ruben.* Bunnell Street Arts Center, Homer, Alaska

1989 *Out of Tradition: Abraham Anghik/David Ruben Piqtoukun,* The Winnipeg Art Gallery, Winnipeg, MB

Group Exhibitions

2011 Inuit Modern: The Collection of Samuel and Esther Sarick, Art Gallery of Ontario, Toronto, ON

2010 The Winnipeg Art Gallery, Winnipeg, MB

2010 Winter Olympics, Canada's Northern House, Vancouver, BC

2009 *Yua: Spirit of the Arctic: Eskimo and Inuit Art from the Collection of Thomas G. Fowler,* De Young Museum, San Francisco, CA

2007 *Inuit Sculpture Now,* Touring exhibition, National Gallery of Canada, Ottawa, ON

2007 *ItuKiagattal! Inuit Sculpture from the Collection of the TD Bank Financial Group,* Victoria Art Gallery, Victoria, BC

2004 *Noah's Ark,* National Gallery of Canada, special exhibition at Shawinigan, QC

1997 Sun Valley Centre for Arts and Humanities, Ketchum, Idaho

1995 *Canadian Inuit Sculpture: The Next Generation,* Orca Art Gallery, Chicago, IL

1993 *Arts from the Arctic,* organized by the Canadian National Committee: Arts from the Arctic, and Prince of Wales Northern Heritage Centre, Yellowknife, NT.

1993 *Arts from the Arctic,* Anchorage Museum, Anchorage, AK

1993 *Arts from the Arctic,* Yakutsk Art Centre, Yakutsk, Republic of Sakha, Siberia

1987 Orcas Gallery, Salt Spring Island, BC

1984 Images Art Gallery, Toronto, ON

1984-88 *Arctic Vision: Art of the Canadian Inuit,* Indian and Northern Affairs Canada, Ottawa, ON. Tour of United States and Canada

1983-85 *Contemporary Indian and Inuit Art of Canada,* Indian and Northern Affairs Canada, Ottawa, ON

1982 *New Work by a New Generation,* Norman Mackenzie Art Gallery, Regina, SK

1982 *Recent Works by Anghik, Morriseau, Odjig, Thomas,* Gallery Quan, Toronto, ON

1982 *Works by Abraham Anghik, David Piqtoukun, Stefanie Ham,* Gallery Quan, Toronto, ON

1981 *The Inuit Sea Goddess,* Surrey Art Gallery, Surrey, BC

1981 Gallery Quan, Toronto, ON

1980 National Museum of Man, Ottawa, ON

1980 Children of the Raven Gallery, Vancouver, BC

1979 Royal Ontario Museum, Toronto, ON

1978 *The Coming and Going of the Shaman,* The Winnipeg Art Gallery, Winnipeg, MB

1977 Art Gallery of Ontario, Toronto, ON

1975 University of Alaska, Fairbanks, AK

Public Collections

Art Gallery of Ontario, Toronto, ON

Canadian Embassy, Washington, DC

Canadian Museum of Civilization, Gatineau, QC

De Young Museum, San Francisco, CA

Glenbow Museum, Calgary, AB

House of Commons, Ottawa, ON

Aboriginal Affairs and Northern Development, Canada, Hull, QC

McMaster University Art Gallery, Hamilton, ON

McMichael Canadian Art Collection, Kleinburg, ON

Museum of Inuit Art, Toronto, ON

National Gallery of Canada, Ottawa, ON

Norwegian Folk Museum, Oslo, Norway

Prince of Wales Northern Heritage Centre, Yellowknife, NT

Royal Ontario Museum, Toronto, ON

The Winnipeg Art Gallery, Winnipeg, MB

University of Alaska, Board of Regents, Juneau, AK

The Vancouver Art Gallery, Vancouver, BC

Bibliography

Alunik, Ishmael, Eddie D. Kolausok, and David Morrison

2003 *Across Time and Tundra: The Inuvialuit of the Western Arctic.* Gatineau, Quebec: Canadian
 Museum of Civilization.

Bockstoce, John

1986 *Whales, Ice and Men: The History of Whaling in the Western Arctic.* Seattle:
 University of Washington Press.

Christensen, Arne Emil

2000 "Ships and Navigation." In Fitzhugh and Ward, *Vikings: The North Atlantic Saga.* Washington, D.C. and
 London: Smithsonian Institution Press.

Driscoll Engelstad, Bernadette

2009 "Shamanism in Ulukhaktok Art." In Dyck, S., and I. Hessel, *Sanattiaqsimajut: Inuit Art from the Carleton
 University Art Gallery Collection.* Ottawa: Carleton University.

2010 "Inuit Art and Nunavut." In McMaster, G., *Inuit Modern: The Samuel and Esther Sarick Collection.* Toronto:
 Art Gallery of Ontario.

Fitzhugh, William W., Aron Crowell, and Julie Hollowell

2009 *Gifts from the Ancestors: Ancient Ivories of the Bering Strait.* Princeton, N.J.: Princeton
 University Art Museum.

Fitzhugh, William W., and Susan A. Kaplan

1982 *Inua: Spirit World of the Bering Sea Eskimo.* Washington, D.C.: Smithsonian Institution Press.

Fitzhugh, William W., and Elisabeth I. Ward

2000 *Vikings: The North Atlantic Saga.* Washington, D.C. and London: Smithsonian Institution Press.

Jorgensen, Lars

2000 "Political Organization and Social Life." In Fitzhugh and Ward, *Vikings: The North Atlantic Saga.*
 Washington, D.C. and London: Smithsonian Institution Press.

McGhee, Robert

1984 "Thule Prehistory of Canada." In Damas, D. editor, *Arctic: Handbook of North American
 Indians,* vol. 5. Washington, D.C.: Smithsonian Institution Press.

1996 *Ancient People of the Arctic.* Vancouver, B.C.: UBC Press.

McMaster, Gerald

2010 *Inuit Modern: The Samuel and Esther Sarick Collection.* Toronto: Art Gallery of Ontario.

Morrison, David, and Georges-Hebert Germain

1995 *Inuit: Glimpses of an Arctic Past.* Hull, Quebec: Canadian Museum of Civilization.

Nuligak
1966 *I, Nuligak*. Edited and translated by Maurice Metayer, omi. Toronto: Peter Martin.

Nweiia, Martin
www.narwhal.org
www.web.med.harvard.edu/sites/RELEASES/html/12_13nweeia.html

Pannese, Rocco, and Abraham Anghik Ruben
2012 Abraham Anghik Ruben: Biographical Sketch. Unpublished manuscript.

Price, Neil S.
2000 "Shamanism and the Vikings." In Fitzhugh and Ward, *Vikings: The North Atlantic Saga*. Washington, D.C. and London: Smithsonian Institution Press.

Rasmussen, Knud
1929 *The Intellectual Culture of the Igloolik Inuit*. Copenhagen: Gyldendal.

Ruben, Abraham Anghik
2008 *Abraham Anghik Ruben: Myths, Stories, Legends*. Vaughan, Ontario: Kipling Gallery.
2010 *Abraham Anghik Ruben: Shaman's Dreams*. Mississauga, Ontario: Art Gallery of Mississauga.

Schaeff, Catherine M.
2007 "Courtship and Mating Behavior." In *Reproductive Biology and Phylogeny of Cetacea: Whales, Dolphins and Porpoises*. Enfield, N.H.: Science Publishers.

Schledermann, Peter
2000 "Ellesmere: Vikings in the Far North." In Fitzhugh and Ward, *Vikings: The North Atlantic Saga*. Washington, D.C. and London: Smithsonian Institution Press.

Seidelman, Harold, and James Turner
1993 *The Inuit Imagination: Arctic Myth and Sculpture*. Toronto: Douglas & McIntyre.

Smith, James G.E., and Carmelo Guadagno
1980 *Arctic Art: Eskimo Ivories*. New York: Museum of American Indian.

Sutherland, Patricia D.
2000 "The Norse and Native North Americans." In Fitzhugh and Ward, *Vikings: The North Atlantic Saga*. Washington, D.C. and London: Smithsonian Institution Press.

Tunis, Roslyn
2010 "The Sculpture of Abraham Anghik Ruben: Reflections of Transformation in the Culture and Art of the Arctic." In *Abraham Anghik Ruben: Shaman's Dreams*. Mississauga, Ontario: The Art Gallery of Mississauga.

Vesteinsson, Orri
2000 "The Archaeology of *Landnam*: Early Settlement in Iceland." In Fitzhugh and Ward, *Vikings: The North Atlantic Saga*. Washington, D.C. and London: Smithsonian Institution Press.

Wallace, Birgitta Linderoth
2000 "The Viking Settlement at L'Anse aux Meadows." In Fitzhugh and Ward, *Vikings: The North Atlantic Saga*. Washington, D.C. and London: Smithsonian Institution Press.

Wight, Darlene Coward
1989 *Out of Tradition*. Winnipeg, Manitoba: The Winnipeg Art Gallery.
2001 *Abraham Anghik Ruben*. Winnipeg, Manitoba: The Winnipeg Art Gallery.

Acknowledgments

The exhibition, *Arctic Journeys, Ancient Memories: Sculpture of Abraham Anghik Ruben*, has received generous financial and material support from the following:

Colour Innovations Inc.

Sprott Asset Management LP

Ready-Weld Metal Fabricators Inc.

George Kriarakis & Associates Ltd.

Troshan, Inc.

Venture Metal Works Inc.

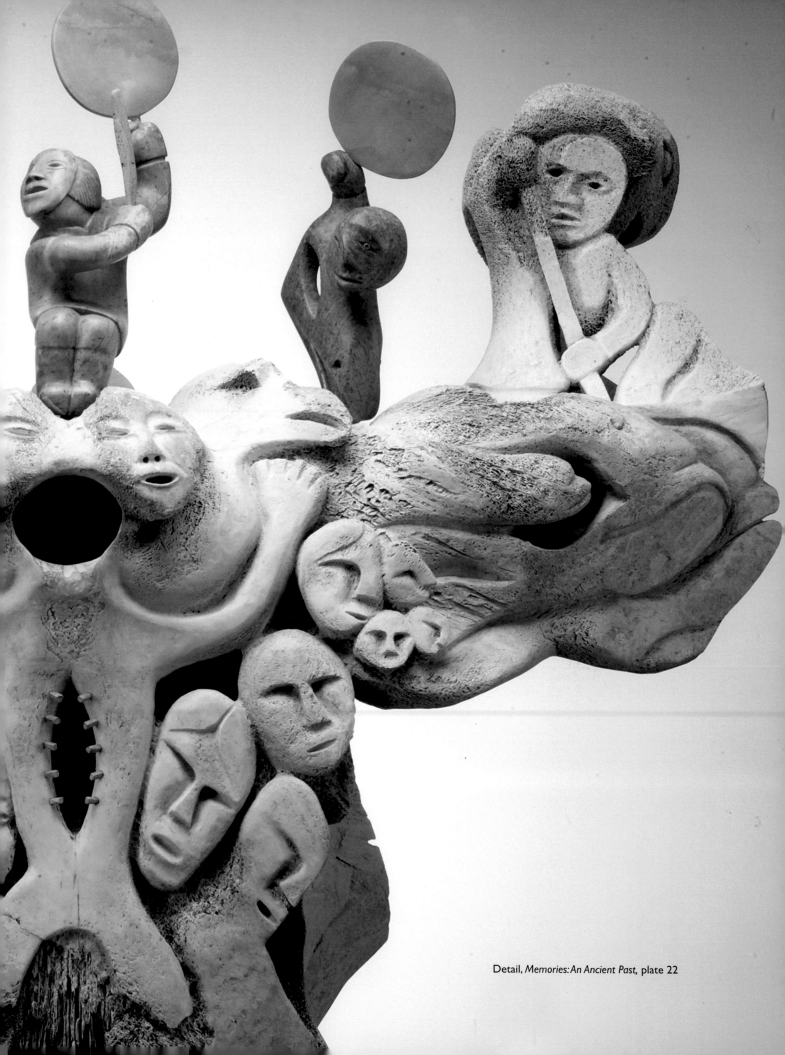

Detail, *Memories: An Ancient Past*, plate 22